IMAGES
of America

# CHICAGO'S JEWISH
# WEST SIDE

To Susie
With love from Mom

Inny Cutler

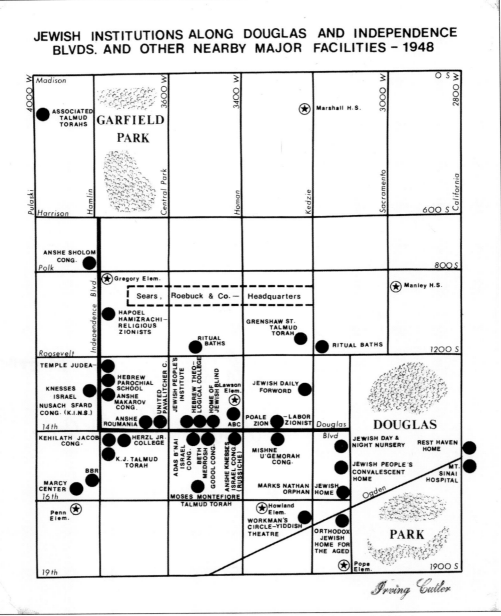

# JEWISH INSTITUTIONS ALONG DOUGLAS AND INDEPENDENCE BLVDS. AND OTHER NEARBY MAJOR FACILITIES – 1948

Major Jewish and other institutions in the heart of the Lawndale–Garfield Park area are seen in 1948 just before many of the Jewish institutions started leaving. There was a strong concentration of Jewish institutions along Douglas and Independence Boulevards. Shown later is the area to the west between Pulaski Road and the industrial belt along Kostner Avenue where the Jewish population was less dense than that east of Pulaski Road. Jewish institutions are depicted by black circles and public schools by stars. (Author's collection.)

*On the cover*: Isadore and Lillian Greenberg's mom-and-pop grocery store was located on Hamlin Avenue opposite Garfield Park in 1940. (Courtesy of Debra M. Greenberg.)

IMAGES
*of America*

# CHICAGO'S JEWISH WEST SIDE

Irving Cutler

ARCADIA
PUBLISHING

Published by Arcadia Publishing
Charleston, South Carolina

Printed in the United States of America

Library of Congress Control Number: 2009924653

For all general information contact Arcadia Publishing at:
Telephone 843-853-2070
Fax 843-853-0044
E-mail sales@arcadiapublishing.com
For customer service and orders:
Toll-Free 1-888-313-2665

Visit us on the Internet at www.arcadiapublishing.com

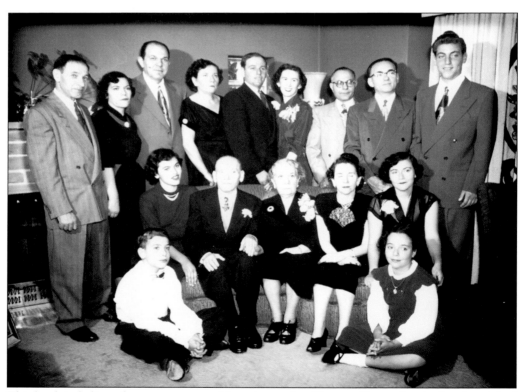

This book is dedicated to my parents and four sisters who, like myself, were inspired and enriched by their three decades of living on Chicago's memorable Jewish West Side. The photograph above shows the immigrant Cutler parents and the five siblings and their spouses and children—all Lawndale residents. (Author's collection.)

# CONTENTS

Acknowledgments     6

Introduction     7

1.    Physical Features     11

2.    Institutions and Residences     27

3.    People     45

4.    Commerce, Industry, and Labor     71

5.    Recreation and Entertainment     85

6.    Events     97

7.    Exodus     109

Bibliography     127

# ACKNOWLEDGMENTS

I have many warm memories of growing up in the North Lawndale part of Chicago's Jewish West Side, as do thousands of others who lived in this largest of all Jewish communities of Chicago. But that was more than half a century ago, and still no general photographic history has ever been made of this remarkable community. To keep its memory alive and preserved while there are still those who remember the community and have stories to tell and photographs to supply, and to pass on to our children and grandchildren what to many was a vital part of their roots, I decided to try to depict through photographs and text what life was like in the greater Lawndale area. The community is gone but not forgotten, and remnants are etched in the hearts and minds of the thousands of immigrants and their offspring who lived there. This book should give them a chance to relive, even though vicariously, the good old days when Lawndale was the great center of Jewish Chicago.

Most of the book's images come from my extensive collection. The other photographs are duly credited and come mainly from Julia Bachrach of the Chicago Park District, Charles Leeks and Matt Cole of the Neighborhood Housing Services of Chicago, Joy Kingsolver of the Chicago Jewish Archives, the Jewish Federation of Metropolitan Chicago, the American Jewish Historical Society, the Richard J. Daley Special Collections Department at the University of Illinois at Chicago, the Chicago History Museum, the Chicago Jewish News, the Sentinel Publishing Company, the Chicago Public Library, the Hebrew Theological College, the Theatre Historical Society of America, photographer Debra M. Greenberg, Lawndale preservationist Sherwin Schwartz, photographer Robert Packer, Judy Harris, Doris Asher, Zelda Bachrach, Pearl Hirshfield, Dr. Julius Wineberg, Leah Wexler, Shirley Tobias, Sandy Aronson, Mark Shulman, Janice Schurgin, Sid Bass, Sid Sorkin, Michele Vishny, Jerome Robinson, Myrna Siegel, and Sheldon Robinson.

The works of members of the Chicago Jewish Historical Society and especially their book *A Walk to Shul* by Bea Kraus and Norman D. Schwartz was most helpful. I am also thankful for the good advice, suggestions, and perceptive criticism from Arlene Goldberg, Joab Silverglade, Paul Lane, Rahm Silverglade, Martin Fischman, and my son Daniel Cutler.

A very special thanks goes to my daughter, Susie Cutler, who spent many hours typing, retyping, proofreading, and making valuable suggestions throughout the evolvement of the book.

Irving Cutler
April 2009

# INTRODUCTION

Whether they now live along Lake Shore Drive or in West Rogers Park, Flossmoor, or Highland Park, many Jews can trace their roots to Chicago's Jewish West Side. It was by far the largest, most concentrated Jewish community Chicago ever had—or probably ever will have. Jews lived there in large numbers for about half a century from 1910 to nearly 1960, and at one time, some 40 percent, or about 110,000, of the entire Chicago area Jewish population resided there.

To most Jews who once lived in the "Great Vest Side," it is remembered as a spirited, pulsating, communally active Jewish neighborhood with over 70 synagogues and countless other Jewish facilities, and while not as economically upscale as the South Side and North Side Jewish communities, it had a vibrant, intense Yiddishkeit that has never been duplicated. By 1930, its proportion of foreign-born population, about 45 percent, mainly Jews from eastern European shtetlach and towns was higher than that of any other Chicago community, and it was one of the most densely populated communities in Chicago.

These Jews, coming primarily from the poverty, pogroms, and restrictions of their eastern European homeland, first settled mainly in the crowded but colorful Maxwell Street area. Then, with economic improvement, most moved westward about three miles to better areas on the city's West Side. There the Jews were heavily concentrated mainly in what is officially recognized as North Lawndale, whose irregular boundaries stretched approximately from California Avenue (2800 West) to Cicero Avenue (4800 West) and from Arthington Street (900 South) to Cermak Road (2200 South). The Jewish community also at its broadest delineation spilled over somewhat into the adjacent East and West Garfield Park communities directly to the north and slightly to the south in South Lawndale and farther to the west in Austin, where in 1940 some 8,000 Jews lived in the vicinity of Columbus Park.

Despite some initial opposition by the gentiles to Jewish entrance into their communities, once a Jew moved onto a block, the block quickly changed to virtually all Jewish. By 1920, the center of the Jewish West Side, North Lawndale, was predominantly Jewish with Yiddish in various accents heard everywhere but much less so in the adjacent West Side communities.

Unlike the Maxwell Street area, North Lawndale had no wooden firetraps, pushcart merchandising, or sweatshops. It was a relatively new, quiet residential community with Douglas and Franklin Parks and the more distant Garfield and Columbus Parks. North Lawndale had two spacious parklike boulevards, Douglas and Independence (its "Lake Shore Drive"), and streets lined with a few apartment buildings but with many two-flat and three-flat brick homes featuring light and airy rooms with front and back porches and backyards bordering alleys. The immediate community had very little industry, but its perimeter was largely encircled by belt railroads that attracted industry. On the community's border were the huge facilities of such companies as the Western Electric Company, Sears, Roebuck and Company, International Harvester Company, Kuppenheimer and Company, and Dryden Rubber Company. Of these, Sears, with some 10,000 employees, was the only one where many Jews worked because of the nature of its operation and because Julius Rosenwald was the top executive for many decades.

As Jews moved rapidly into North Lawndale, by the 1930s most of the elementary schools' students were Jewish. Along the two boulevards were about a dozen synagogues, many in imposing classical architecture, and all but one, the Reform Temple Judea, being Orthodox. Also on the boulevards, opposite each other at Douglas Boulevard and St. Louis Avenue, were the large, very

active Jewish People's Institute (JPI) and the Hebrew Theological College. At the junction of the two boulevards were Kehilath Jacob Congregation and Theodore Herzl Junior College, to which most of the Jewish high school graduates went. Opposite Theodore Herzl Junior College was the "mansion" of the powerful political boss of the 24th Ward Democratic Organization, Ald. Jacob Arvey. In the 1936 presidential election, his highly efficient Democratic organization turned out 26,112 votes for Franklin Delano Roosevelt and only 974 votes for Alfred Landon, with Roosevelt calling the ward "the number one ward in the Democratic Party."

On major Jewish holidays, the boulevards were crowded with people in their finest dress, clustering around the synagogues, with the young folks strolling from synagogue to synagogue visiting their parents, grandparents, and friends. On Sukkoth, the festival celebrating the completion of the harvest, men were seen in the morning rushing to their synagogues with a *lulav* (palm branch) and *etrog* (citron fruit) in their hands.

There was a hierarchy of shopping in the area, mainly at Jewish-owned stores, ranging from the mom-and-pop grocery, delicatessen, or fruit store to commercial-lined streets such as Kedzie Avenue, Sixteenth Street, and Crawford Avenue (later Pulaski Road) to the mile-and-a-half major commercial Roosevelt Road. Kedzie Avenue at its junction with Ogden Avenue had the multiuse Douglas Park Auditorium; farther north at Thirteenth Street was the home of the *Jewish Daily Forward* and of Jewish labor unions, and farther north at Adams Street was John Marshall High School. At Madison Street were Little Jack's Restaurant (famous for its cheesecake) and the Senate Theater. Additionally, all along Kedzie Avenue were kosher butcher shops, fish stores, bakeries, groceries, fruit stores, drugstores, and delicatessens. Sixteenth Street's east end started opposite Douglas Park, and at Kedzie Avenue was the White Palace Theater, and farther west, in addition to the general consumer stores, were two small department stores (W. W. Department Store and Wallace Department Store) and also the George Howland and William Penn Elementary Schools. Crawford Avenue had the large and popular Berger shoe store.

Roosevelt Road from California to Kostner Avenues was the bustling main shopping street of North Lawndale. It contained numerous movie theaters, banquet facilities such as the Café Royale and the Blue Inn Café, numerous second-floor meeting halls, restaurants such as Sam and Hy, Fluky's, Silversteins Delicatessen, Carl's, Zweig, Gwirtz, Joe Stein's Romanian, and the favorite especially of the young, Ye Olde Chocolate Shop. There were also a number of clothing, furniture, Jewish book, and dime stores. For the gamblers there were, among others, Zookie the bookie, Davy Miller's Pool hall, and Puddy's. Those wanting extra-special shopping facilities went to the Madison-Crawford area where there were two large department stores, Madigan and Goldblatt Brothers, in addition to two large Balaban and Katz theaters, the Marbro and the Paradise.

Albany Avenue, directly west of Douglas Park, was a street lined with numerous Jewish institutions, including the Douglas Park Jewish Day and Night Nursery, the Jewish People's Convalescent Home, and the Marks Nathan Jewish Orphan Home. The latter well-equipped facility handled 300 boys and girls who were well housed, fed, dressed, and educated, with many becoming successful, prominent adults. Also on Albany Avenue, south of Ogden Avenue, was the very large Orthodox Jewish Home for the Aged, which occupied almost a full block opposite the park.

On California Avenue, on the east side of Douglas Park, Mount Sinai Hospital was opened in 1912, established primarily by eastern European Jews who wanted a kosher facility of their own in lieu of the German Jewish–founded Michael Reese Hospital on the South Side where the eastern European Jews often felt uncomfortable. Across the street was Rest Haven (now the Schwab Rehabilitation Center).

In addition to about a dozen larger synagogues on the two boulevards, there were another 60 or so on the side streets, all Orthodox. Some were large, others were *shtiebl* synagogues, often a room in a rabbi's home used for praying and studying. The synagogues usually bore the names of the communities in eastern Europe where the founding members came from, although a few synagogues were founded by concentrations of certain craftsmen such as carpenters or laundrymen.

The synagogues, in addition to their religious functions, also had health, loan, welfare, and funeral/cemetery benefits along with being social and meeting centers. During the Great Depression of the 1930s, when unemployment and poverty were prevalent, poor Jews were aided by Jewish charities, the government, and even by the 24th Ward Democratic Organization. Families who had little themselves often gave to others who had even less. But many unable to pay their mortgages lost their homes, and renters who could not pay their rents were often evicted with all their belongings placed outside on the sidewalk. Suicide was sometimes a way out for the most despondent.

Despite periods of hardship, the Jews of Lawndale consistently had a wide variety of interests and activities. The area bustled with Zionist groups, reading groups, religious organizations, social and athletic clubs, political groups, dozens of *vereins* (organizations usually of people from the same community in the old country), and numerous forms of entertainment in movies, Yiddish theaters, dances, ball games, and card games. Street orators of almost every political persuasion were often pontificating on soapboxes on Roosevelt Road.

The youngsters, besides attending the public schools and Hebrew schools, also participated in the activities of the Boys Brotherhood Republic (BBR), the American Boy's Commonwealth (ABC), and Marcy Center (a non-Jewish youth center). They often played baseball or football on the streets, in the schoolyards, or in the parks.

A major focal place of activities was the JPI, the successor to the Chicago Hebrew Institute of the Maxwell Street era. Jews of all ages participated in its educational, social, cultural, and recreational functions. The JPI had a large auditorium, gymnasium, swimming pool, library, Jewish museum, and restaurant called the Blintzes Inn. It had a theater group, concert orchestra, classes and lectures in English, Yiddish, and Hebrew, a day and summer camp, and 70 different organizations were headquartered there. Prominent people from writers, artists, educators, and athletes to politicians and business leaders could be found there. These included Leo Rosten, Ald. Jacob Arvey, Todros Geller, Louis Wirth, Benny Goodman, Nelson Algren, Stuart Brent, Barney Ross, Judge Abraham Lincoln Marovitz, Maurice Goldblatt, and others. One of the favorite events was the roof garden dance every Sunday evening in the summer—where many a lasting match was made.

The North Lawndale community was especially alive with outdoor activities during the warmer months. Through the alleys came a procession of horse-drawn wagons or trucks with peddlers shouting their fruit and vegetable wares. Tagging along would be the iceman, the milkman, and the "ragsoline" man (rags/old iron collector). Occasionally the knife sharpener, the umbrella man, the soda pop truck, and the coal truck, dumping a pile of coal in front of the house, would also come. During the day, homes were visited by collectors of telephone-box coins, insurance premiums, and *pushkas* (small metal collection boxes with donations for Jewish causes). Occasional visits were made by soul-hunting Christian missionaries who had negligible success. Itinerant fiddlers played Yiddish melodies in the yard and were rewarded by housewives who would throw them a few coins wrapped in paper.

Sound trucks announced the movies at the local air-conditioned theaters. During election periods, the trucks would come by promoting candidates or urging participation in the election for the various Zionist party candidates. There was great interest in a Jewish homeland in Palestine that increased as the Nazis came into power. The creation of the State of Israel in 1948 was the most joyous occasion of the era, with huge rallies and a sharp increase in fund-raising.

In the evening, people sat on their front porches, usually chatting with their neighbors. Almost everyone on the block was known as well as their family histories, successes, and struggles. And along the street, especially during the Depression, came a procession of vendors selling ice-cream bars for a nickel, or candy, or occasionally waffles. On sweltering summer nights, before air-conditioning or the ubiquitous prevalence of automobiles, people often took their pillows and slept in Douglas or Garfield Parks or along the boulevard parkways. There usually was plenty of company and no fear in those days. Those who could afford it would often "go to the country"—rent a cottage or stay in a resort in the Indiana Dunes area or in Union Pier or

South Haven, Michigan. The husband would come on the weekends, usually loaded down with food and other needed supplies.

World War II and its aftermath brought major changes to the community. During the war, thousands of Jews joined all branches of the armed forces, some worked in defense plants, and others volunteered in war effort causes. A sizable percentage of the 45,000 Chicago-area Jews who served during the war as well as the 1,000 who got killed and 2,000 who received Purple Hearts were from the Jewish West Side.

The postwar period was generally one of prosperity and witnessed the gradual removal of many of the restrictions against Jews as to residential, employment, and educational opportunities. Many of the servicemen took advantage of the educational GI Bill of Rights to further their educations and to enter the professions and business, and with traditional hard work, upward mobility, and middle-class status became common.

Although North Lawndale continued to be physically a very pleasant neighborhood with an abundance of Jewish institutional facilities, the postwar period witnessed a Jewish exodus from the area. As quickly as the area had changed from gentile to Jewish in the early decades of the century, just as rapidly did the community change in midcentury from largely Jewish to African American. By 1960, except for some Jewish business establishments, the Jews had all left North Lawndale and soon the rest of the Jewish West Side.

Leaving was part of a general trend of many ethnic groups in the city. With prosperity, families sought to move upward to better areas with better schools and other more favorable amenities. They were seeking homes of their own with more indoor and outdoor space. In the case of North Lawndale, there were very few single-family homes. Many veterans took advantage of government financial incentives to buy their own homes. So they started moving out to areas presumed more upscale such as South Shore and to the north to Albany Park, Rogers Park, West Rogers Park, and to suburbs such as Lincolnwood, Skokie, and beyond—areas that were available to Jews and where they reestablished their institutions. As vacancies occurred in North Lawndale, the rapidly growing African American population that had been restricted to limited crowded areas mainly to the east started moving into North Lawndale and nearby areas, and the change accelerated rapidly. But unlike other changing neighborhoods where violence occurred, the transition was peaceful and without incident.

Many of the younger American-born children of the immigrants were not interested in clinging to the neighborhood and great institutional structures their parents and grandparents had labored so hard to build. Many of the younger generation were more interested in the American way than in the Yiddish, religious, Old World traditions of their ancestors, so they moved onward, leaving the structures to the newcomers who have converted the synagogues into churches and continue to use the youth centers and other institutional buildings.

The riots after the assassination of Dr. Martin Luther King Jr. in 1968 devastated the community. Whole commercial blocks were burned out. Many of the homes deteriorated and were torn down, leaving thousands of vacant lots. While the population of North Lawndale during the Jewish period was consistently well over 100,000, the 2000 census showed it at fewer than 40,000 and with limited commercial and employment facilities. However, in recent years, there has been sporadic redevelopment in North Lawndale and the adjacent West Side communities. A number of new schools have been built, large private developments of homes have been developed around the old Sears, Roebuck and Company complex, opposite Douglas Park, and in other parts of the area. Burned-out Roosevelt Road is coming back with a number of private and also chain stores, although a new Dominick's, Starbucks, and movie complex on the street have recently closed. The area has a number of very active community organizations that are trying to improve the neighborhood, housing, and education and to rid it of crime and drugs.

Chicago's Jewish West Side, like Maxwell Street before it, no longer exists as a Jewish community, except in the minds of the Jewish immigrants and their thousands of scattered offspring who remember it as the heart of Jewish Chicago.

# *One*

# PHYSICAL FEATURES

The prairie land of Lawndale started growing as an urban settlement after the Great Fire of 1871. The new development of fireproof brick buildings attracted many people and businesses that had been burned out by the fire. Real estate firm Millard and Decker subdivided some of the area and advertised it as Lawndale—a place linking in "harmonious union the people of a community."

The company extolled the virtues of the new area, such as landscaping, lake water from the Chicago waterworks, transportation via Ogden Avenue and the Chicago, Burlington and Quincy Railroad (1864), and the soon-to-be-implemented Douglas Park "L" (1896) and the Garfield Park "L" (1895). As the population grew, a few horsecar lines served the area and later one cable car line on Madison Street reaching as far west as Crawford Avenue. Starting in 1892 the electric streetcar began replacing other modes of transportation, and the West Side area soon had streetcar lines running on all major streets. Beginning in the early 1920s, the Chicago Motor Coach Company started running buses on Jackson and Douglas Boulevards, which terminated downtown. In time, no one lived more than a few blocks from public transportation.

One of the major selling points of the area was the parks. Plans for the West Side parks were completed by William LeBaron Jenney in 1871. Douglas Park opened in 1879 in the eastern part of North Lawndale. Additions to the park were later made by Jens Jensen. Among its many features was one of the city's first public bathing facilities. Farther north was Garfield Park, to which Jensen added in 1908 the popular haystack-shaped Garfield Park Conservatory. The two parks were connected by Douglas and Independence Boulevards, which in time housed many of the largest institutions and some of the finest residential facilities. The smaller Franklin Park featured an outdoor swimming pool and served the western part of North Lawndale.

With these amenities, its closeness to downtown, and the establishment of job-producing large plants on the periphery near the railroads, North Lawndale reached a population of 46,225 by 1910, mainly people of Bohemian, Irish, and Polish descent. The following decade started witnessing a major ethnic change as thousands of eastern European Jews, coming primarily from the Maxwell Street area, started moving in. Half a century later, its population had tripled.

# Millard & Decker's
# LAWNDALE SUB-DIVISION

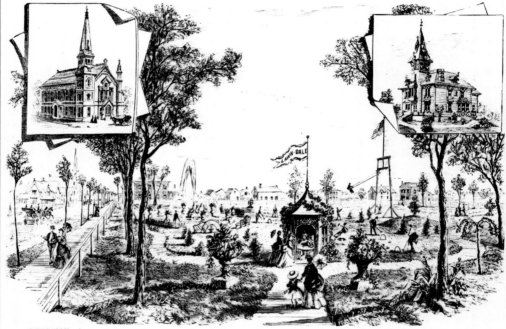

T HE above cut represents a few of the Improvements near DOUGLASS PARK, in the south-west part of Chicago, known as LAWNDALE. Two years since this section was open prairie, having neither Houses, Trees, Roads or Fences. The property is supplied with LAKE WATER FROM CITY WATER-WORKS, and A GOOD SCHOOL under the direction of the City Superintendent. Is on Ogden Avenue, and the CHICAGO, BURLINGTON AND QUINCY RAILROAD. Fine drive and frequent trains afford good communication with the CENTER OF THE CITY. We have made almost the entire improvements, and point with pride to the success of the enterprise. There is no part of the City where you can invest and be so sure of a RAPID ADVANCE on your investment as in our Sub-Division. We are building houses and selling them on very easy terms.

## WE ALSO MAKE A SPECIALTY OF LOANS,

AND CAN PLACE ANY AMOUNT WITH THE BEST OF SECURITY AT THE HIGHEST MARKET RATE.

## MILLARD & DECKER, Real Estate Dealers,

*Room 5, Republic Life Insurance Building, Chicago.*

The real estate firm of Millard and Decker started subdividing parts of Lawndale in 1870 and gave the area its name. Shortly thereafter, the aftermath of the Great Fire of 1871 and the opening of the large McCormick Reaper Works nearby in 1873 and later other neighboring large plants brought an influx of settlers into the area. The advertisement stressed Douglas Park, good transportation, and lake water for the area. Before Millard and Decker's development, the area had been sparsely occupied by a few Dutch and English farmers and also by a small number of scattered cottage-type residences.

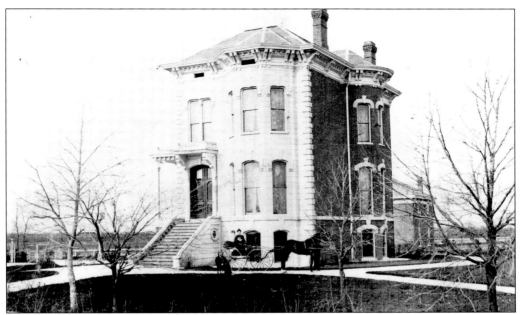

This photograph shows an isolated single-family home in Lawndale around 1870, when the area was just starting to be settled. (Courtesy of the Neighborhood Housing Services of Chicago.)

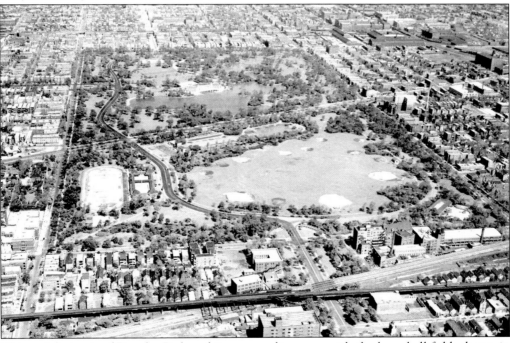

This aerial view is of Douglas Park and its surrounding area, with the large ball fields shown in the center and the field house and lagoon farther back. A disabled small airplane once made a successful landing in the ball field. The foreground shows the Chicago, Burlington and Quincy Railroad tracks going under the Douglas Park "L." Rowboats could be rented at the field house for a quarter an hour. (Courtesy of the Chicago Park District.)

Here is one of the several bridges that were constructed in Douglas Park during the late 19th century. Before the coming of the automobile, the neighborhood parks were especially popular. On hot summer nights before air-conditioning, people took their pillows and slept in the parks. (Courtesy of the Chicago Park District.)

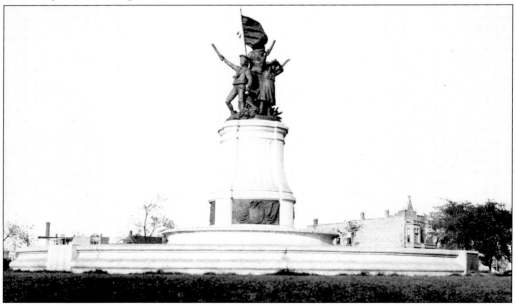

The bronze American youth and Independence Day fountain sculpture by Charles J. Mulligan was unveiled on July 4, 1902, at the intersection of Douglas and Independence Boulevards. It features two boys and two girls celebrating the Fourth of July. It later became a meeting place on Friday evenings for young Jewish people who would sing and dance there into the late hour of the night. (Courtesy of Sherwin Schwartz.)

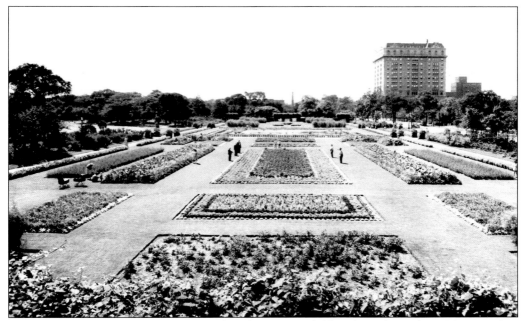

Jens Jensen created the beautiful formal gardens in Garfield Park in the early 1900s, complete with flower beds and water courts. It was the site of an outdoor sculpture exhibit cosponsored by the Municipal Art League in 1909. The building in the background was the Midwest Athletic Club. (Courtesy of the Chicago Park District.)

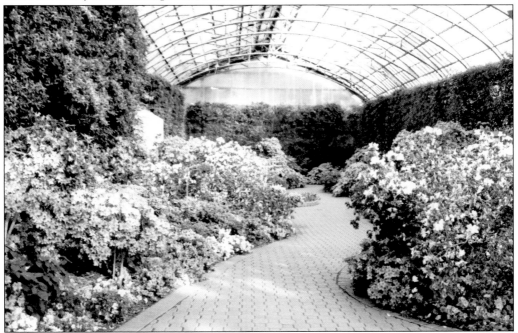

The interior of the Garfield Park Conservatory at 300 North Central Park Avenue is one of the largest under glass in the world. It has had numerous successful indoor and outdoor exhibits and is often visited by botany class students on assignments from area high schools.

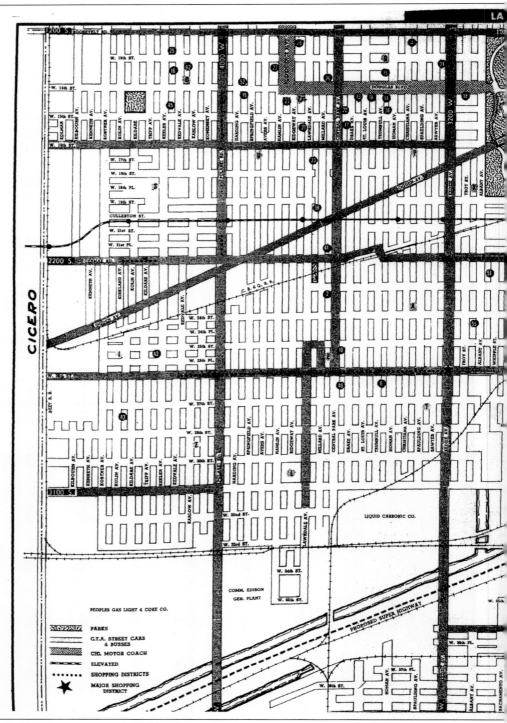

A detailed 1950 street map of the North and South Lawndale communities shows the religious institutions, schools, and other significant facilities of the area. Just east of the county jail and

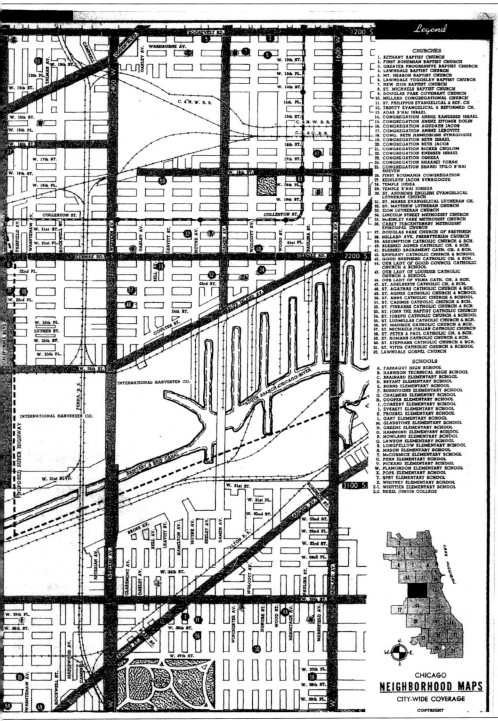

California Avenue was the huge site of the International Harvester Company plant. (Courtesy of the Chicago Real Estate Board.)

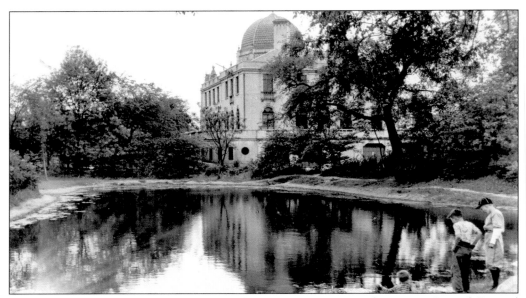

The monumental gold dome building of Garfield Park was constructed in 1928 in Spanish Revival style with a gold leaf dome that reaches a height of 90 feet. It was originally the administrative headquarters of the West Park commissioners until the park districts were consolidated in 1934. It then became a recreational and cultural center with a variety of activities, including hosting a children's summer camp. It recently underwent a major renovation that included reguilding the dome.

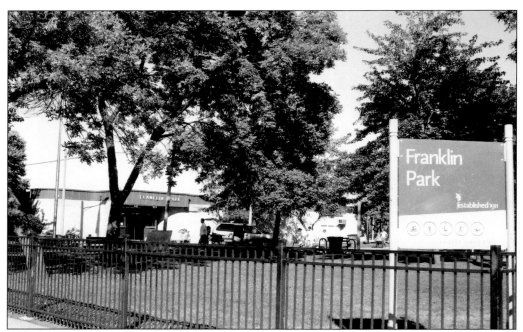

Franklin Park, a small neighborhood park located at Fourteenth Street and Kolin Avenue, mainly served the Lawndale area west of Crawford Avenue (now Pulaski Road). It had a large outdoor swimming pool.

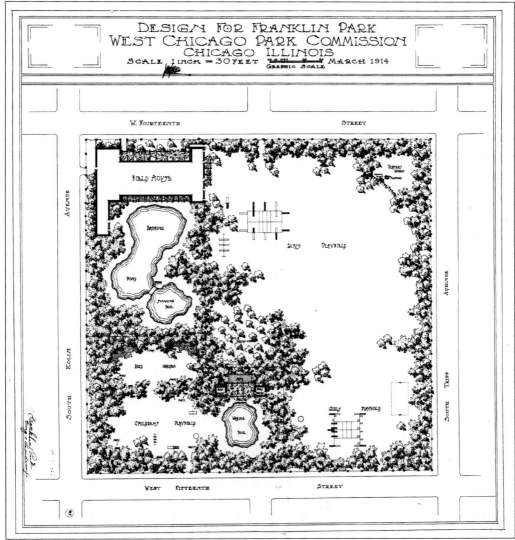

Jens Jensen's 1914 plan for Franklin Park (with his signature on top) featured a number of swimming pools of different depths. The ball field at the right was the site every Sunday morning during the warm months of baseball games played mainly by Jewish young men who also made small monetary side bets as to the outcome. (Courtesy of the Chicago Park District.)

The little park on Arthington Street and Homan Avenue, directly opposite the huge Sears, Roebuck and Company complex, was built and maintained by the company. It was a place where workers could relax, stroll, or eat lunch.

Sokol Hall, located at 2323 South Kedzie Avenue, was the meeting place of the Bohemian Social and Athletic Club. It was near the heart of the Bohemian neighborhood that was centered around Twenty-sixth Street in South Lawndale. (Courtesy of the Chicago History Museum.)

St. Casimer Church and School was located at Cermak Road and Whipple Avenue. Built in 1890, it served the growing Polish population in the Marshall Square area near Douglas Park.

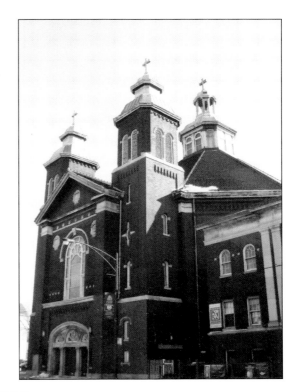

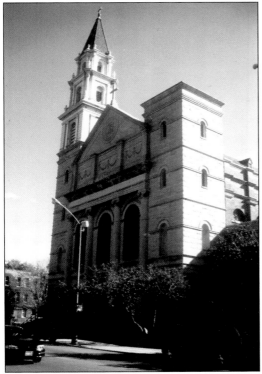

Our Lady of Sorrows Basilica, located at Jackson Boulevard and Albany Avenue, was founded in 1874. With predominantly Irish members at first, it later had many Italian members, and now its members are mainly African Americans. The church built an elementary school and a boys' and girls' high school and has become the National Shrine of Our Sorrowful Mother.

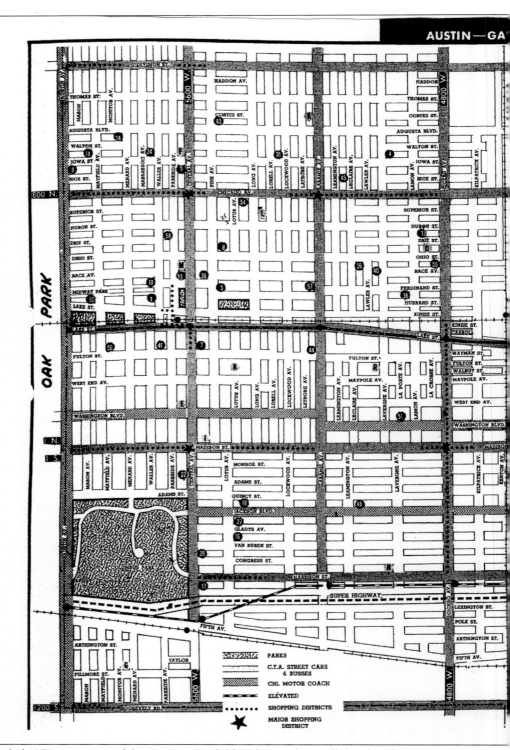

A detailed 1950 street map of the Austin–Garfield Park area shows all the churches, synagogues,

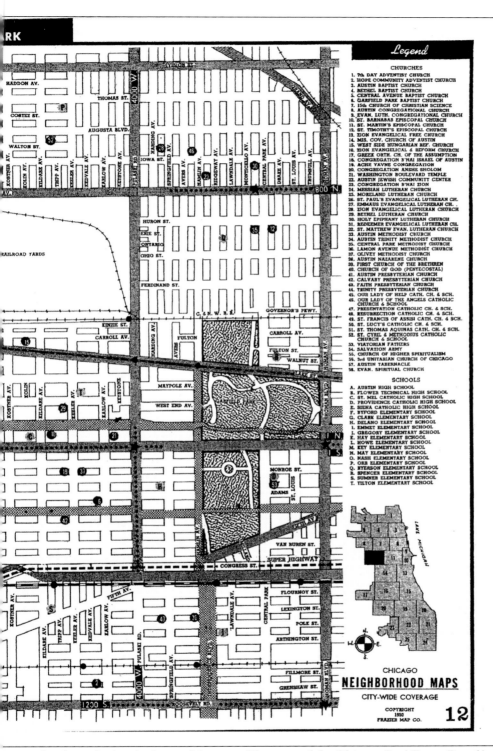

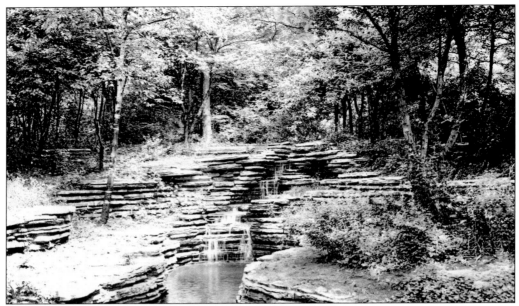

The south waterfall is in Columbus Park, which is located in the Austin community of Chicago. The park was completed in 1920 on 144 acres of previous farmland on Chicago's western boundary. The park was designed by the well-known landscape architect Jens Jensen, whose plan was inspired by the natural landscape surrounding Chicago. The park is a national historic landmark. (Courtesy of the Chicago Park District.)

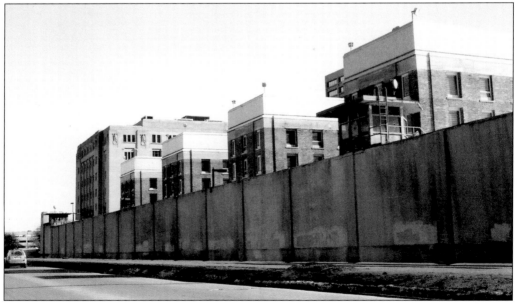

Part of the Cook County jail in South Lawndale opened in 1929 at Twenty-sixth Street and California Avenue. It is one of the largest in the country with usually over 10,000 inmates. This view is looking eastward along Twenty-sixth Street toward California Avenue in 2009. Through the years, the jail has been racked by murders, suicides, waves of other disturbances, charges of racial discrimination, and overcrowding.

Ogden Avenue cuts diagonally through Lawndale. For part of the 1800s it was the Southwest Plank Road, an improved toll road used by the region's Dutch and English farmers. A wide road most of the way, it later became part of the historic Route 66. Through the years, the public was served on the street by streetcars, then buses and also suburban bus lines. The photograph shows the Cook County juvenile center (formerly the Audy Home) located at Roosevelt Road and Ogden Avenue.

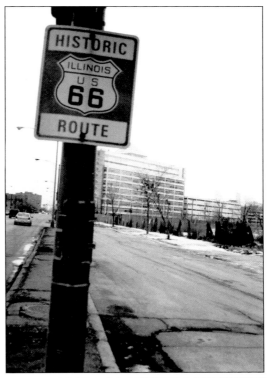

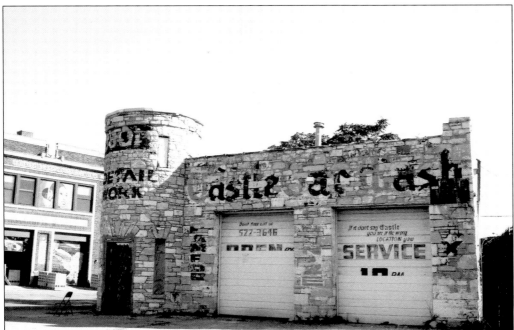

A historic landmark, the former Murphy's filling station (built in 1925) is the last historically intact gas station building along Route 66 in Illinois. Located at 3801 West Ogden Avenue, it later served as the Castle Car Wash and is now vacant.

The Douglas Park "L" opened in 1896 and once ran from downtown to Berwyn with a number of station stops in Lawndale. It still is the fastest public transit route to downtown from Lawndale.

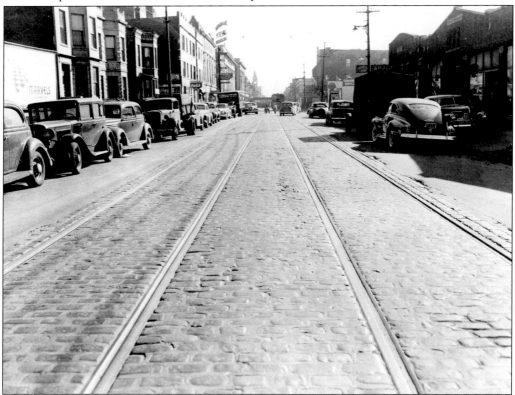

This photograph shows Kedzie Avenue looking south toward the busy intersection of Kedzie Avenue and Roosevelt Road in 1941. Both streets had busy streetcar lines. In the background to the left is the Liberty Bank at the northeast corner of that intersection, and farther south at Douglas Boulevard is the spire of St. Agatha Catholic Church. (Courtesy of Sherwin Schwartz.)

# *Two*

# INSTITUTIONS
# AND RESIDENCES

Lawndale had many institutions and activities that served its people. Near its eastern end was the large Douglas Park with its flower gardens, huge ball fields, field house with its large gymnasium, swimming pool, and lagoon for boating, fishing, and ice-skating. In the summer there were often free band concerts on weekends and occasional picnics. Facing the eastern side of the park was the Orthodox-built Mount Sinai Hospital and also the rehabilitation center Rest Haven.

On the western side of the park on Albany Avenue was a whole alignment of Jewish-supported social service institutions—the Douglas Park Jewish Day and Night Nursery (established in 1919), the Jewish People's Convalescent Home (1932), the Marks Nathan Jewish Orphan Home (1912), and the block-long Orthodox Jewish Home for the Aged (1903). Just south of the latter was Pope Elementary School, one of 10 elementary schools in the area, most by the 1930s having over 2,000 Jewish students, usually more than 90 percent of each school's enrollment. There were also scattered through the territory a similar number of smaller Hebrew and Yiddish schools mainly with afternoon classes.

The region had 72 synagogues, some of large classical style and some small *shtiebls*. The most imposing synagogues were aligned along Douglas and Independence Boulevards, which also had the very active Jewish People's Institute (JPI) across from the Hebrew Theological College and near a number of Zionist and religious organization buildings. Farther west on Douglas Boulevard was Theodore Herzl Junior College, where most of the neighborhood high school graduates, mainly from John Marshall and Hugh Manley High Schools went, with smaller numbers from Harrison, Crane, Austin, and Farragut High Schools. Among the most used facilities of the region were the parks, Douglas, Garfield, Columbus, and Franklin. Columbus Park still has a golf course while Garfield Park's has been replaced by ball fields.

The youngsters used the three major youth centers in North Lawndale. Almost everyone used the two public libraries, the Douglas Park and the Legler. The Douglas Park Auditorium (Labor Lyceum) on Kedzie and Ogden Avenues was a multipurpose building housing the Workmen's Circle, fraternal organizations, Jewish labor unions, Yiddish classes, and the last Yiddish theater in Chicago from 1938 to 1951.

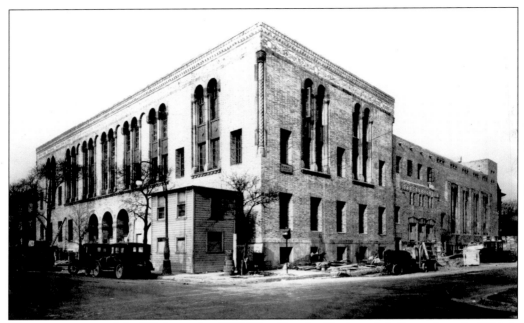

The construction of the JPI, located at 3500 West Douglas Boulevard, is shown here in 1926. It was the successor of the Chicago Hebrew Institute of the Maxwell Street area. People of all ages participated in the social, cultural, and recreation facilities of the JPI. Its many features included a museum, pool, gymnasium, library, theater, and restaurant (the Blintzes Inn).

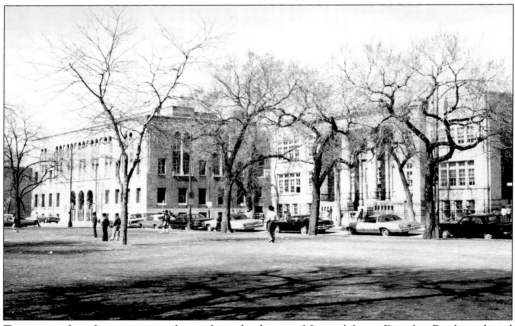

Two major Jewish institutions located in the heart of Lawndale at Douglas Boulevard and St. Louis Avenue were, on the left, the JPI (1926–1955) and, to the right, the Hebrew Theological College (1922–1956).

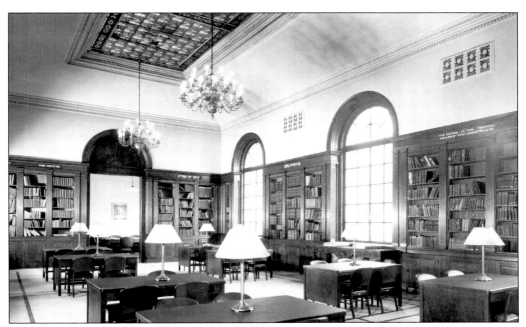

The library located in the Hebrew Theological College, the institution that ordained many of the Orthodox rabbis who served especially in the Midwest, is seen here. (Courtesy of the Chicago History Museum.)

Among the earliest synagogues in Lawndale were shtiebl shuls in the home of a rabbi. The Makarover rabbi's shtiebl synagogue, B'nai Jacob Anshe Makarover, was located on the first floor of his home at 1241 Independence Boulevard near Thirteenth Street. It was fairly common for a rabbi with a following to use a room in his home as a synagogue. This synagogue at the address above was established in 1920 by Polish Jews.

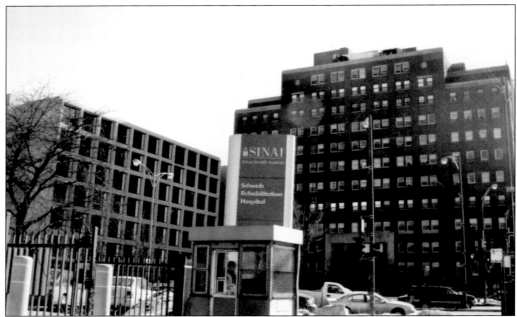

Part of the Mount Sinai Hospital complex located at Fifteenth Street and California Avenue opposite Douglas Park is pictured in 2009. It was built by eastern European Jews in 1912 to serve the burgeoning West Side Jewish population. It has expanded its facilities a number of times and also fostered significant research. It is still partially supported with Jewish funds although only small numbers of Jews are served there. It has helped to stabilize the surrounding neighborhoods and serve their residents. Across the street is the Schwab Rehabilitation Center, which is under the hospital management.

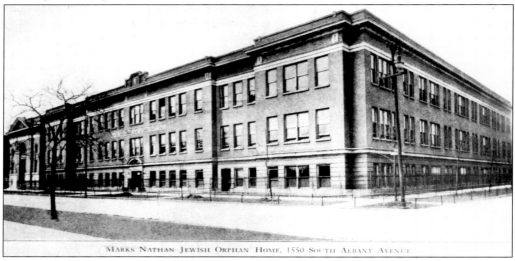

MARKS NATHAN JEWISH ORPHAN HOME, 1550 SOUTH ALBANY AVENUE

The Marks Nathan Jewish Orphan Home at 1550 South Albany Avenue was built opposite Douglas Park in 1912. It was largely funded by a $15,000 bequest from Marks Nathan. It was equipped to handle 300 boys and girls who were well housed and dressed, fed kosher meals, and educated in public schools. The building had its own attached synagogue. Most of its residents adjusted well to adult life and some became very prominent.

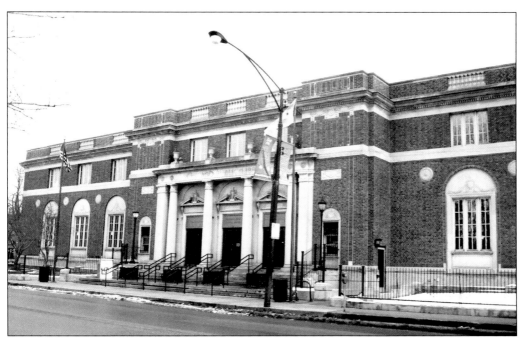

The Legler Public Library at 115 South Crawford Avenue (now Pulaski Road) attracted readers from the Lawndale and Garfield Park neighborhoods. It ran a variety of programs for both adults and children.

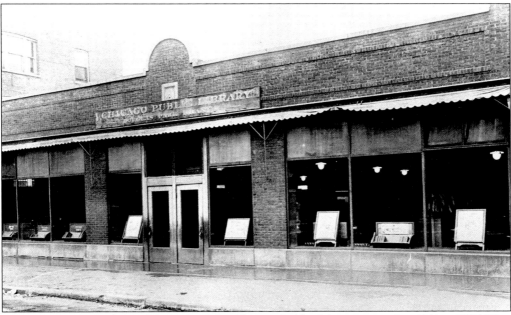

The storefront Douglas Park branch of the Chicago Public Library opened in 1914 at 3315 West Thirteenth Street. Golda Meir worked there as a librarian in the 1920s before leaving for Israel, where she later became prime minister. She was born in Russia and lived in Milwaukee before coming to Chicago.

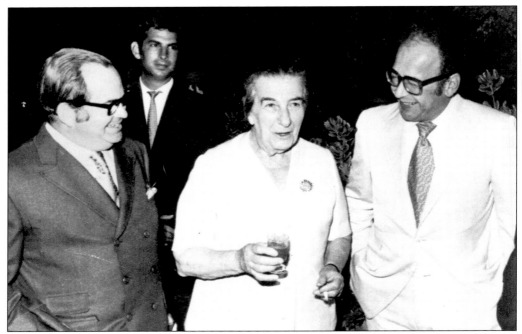

Golda Meir, a former Chicago resident, is welcomed back on her visit to the city in 1968. While living in Chicago, she often frequented the Labor Zionist building at 3322 West Douglas Boulevard.

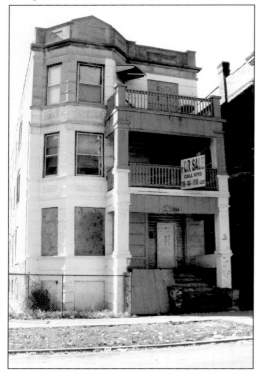

Golda Meir lived in a back apartment of this building at 1306 South Lawndale Avenue in the early 1920s while working as a librarian at the nearby Douglas Park branch library. In 2007, an effort was made, without success, to have the building recognized as a historic landmark by the city.

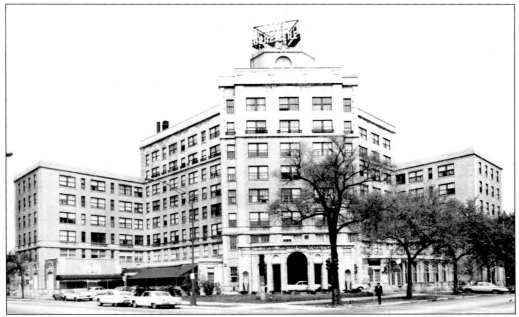

The Graemere Hotel on the northeast corner of Homan Avenue and Washington Boulevard was located just opposite Garfield Park. It was a first-class facility in the area for weddings, bar mitzvahs, and other events.

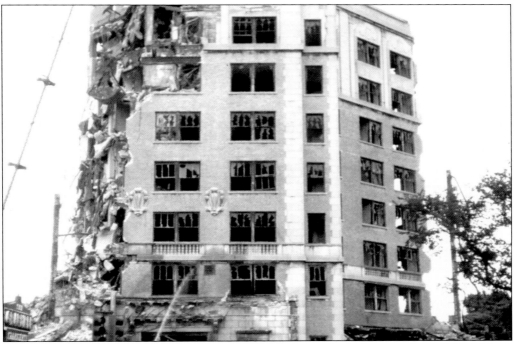

As the neighborhood changed and became quite impoverished, the once beautiful and busy Graemere Hotel located in the East Garfield Park community was torn down in 1978 and later replaced by a large apartment building.

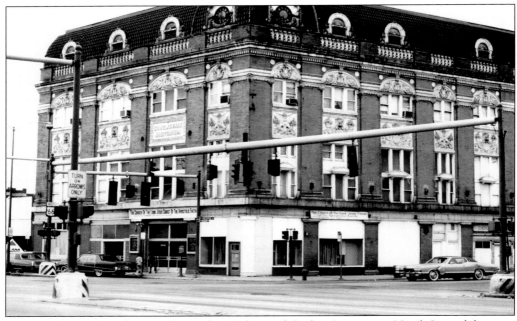

The Douglas Park Auditorium located at Kedzie and Ogden Avenues in North Lawndale was a multipurpose Jewish institutional building. It housed the Workmen's Circle, Jewish labor unions, fraternal organizations, a Yiddish school, and the last Yiddish theater in Chicago from 1938 to 1951.

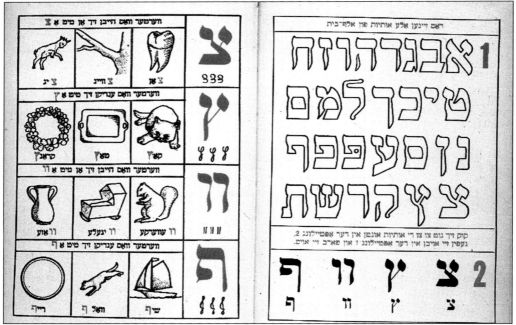

Pictured is a Yiddish lesson used by the educational branch of the Workmen's Circle schools. At the right is the alphabet, and on the left are the Yiddish words for objects. (Courtesy of Sid Sorkin.)

These two-flat greystone buildings were located in the 1800 block of South Millard Avenue in North Lawndale. The block was one of the finest residential streets in North Lawndale. In recent years, the city has made an effort to save the old greystone buildings, which were especially prevalent in the area. (Courtesy of Dr. Julius Wineberg.)

"Kessel Garden" (Castle Garden) was the name given to the large apartment building on Independence Boulevard and Arthington Street where many Jewish immigrants lived. Castle Garden in New York preceded Ellis Island as the place for arriving immigrants.

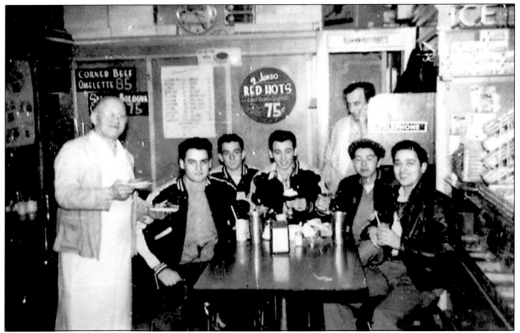

A small delicatessen in the Castle Garden building on Independence Boulevard shows five Chicago Jewish Academy students having snacks. They are, from left to right, Jack Siegel, Jordy Ross, Moishe Rosen, Sam Fieler, and Shael Siegel. (Courtesy of Myrna Siegel.)

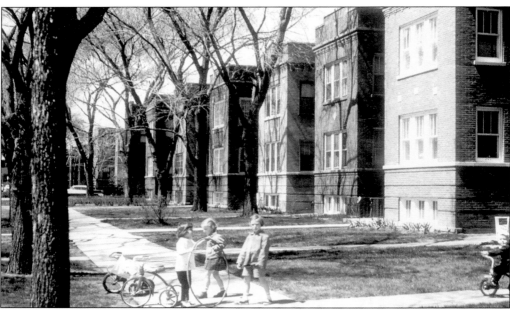

Children play in the Austin community around 1960. Each building housed two families. Austin generally was considered slightly economically above North Lawndale. Austin stretched westward from Cicero Avenue to Austin Boulevard, the community's boundary with Oak Park.

Three institutions important to the Jewish West Side community were located at the intersection of Homan Avenue and Thirteenth Street. To the left is Victor Lawson Elementary School, now replaced by homes, which at one time had about 95 percent Jewish students. To the right is the American Boy's Commonwealth (ABC), a Jewish youth facility, and in the background is the Douglas Public Library, which had a large Yiddish and Hebrew book collection.

The ABC at Thirteenth Place near Homan Avenue was a Jewish youth center run by the Young Men's Jewish Council. The seed money of $100,000 for the building came from Jacob Franks as a memorial to his son Robert Franks, who was murdered by Nathan Leopold and Richard Loeb. Membership averaged 1,200 boys a year who participated there in cultural, athletic, and craft activities. The building now serves the African American boys of the area.

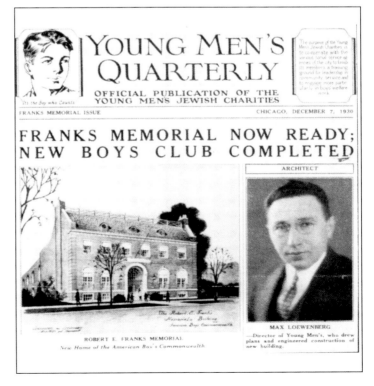

The Boys' Brotherhood Republic (BBR) youth center was located on Hamlin Avenue near Sixteenth Street. It had numerous craft and athletic programs and had a policy of self-government by the boys. In 1966, Dr. Martin Luther King Jr. and his family moved into a three-flat building virtually next door at 1550 South Hamlin Avenue, from which he waged a yearlong struggle for open housing in the city.

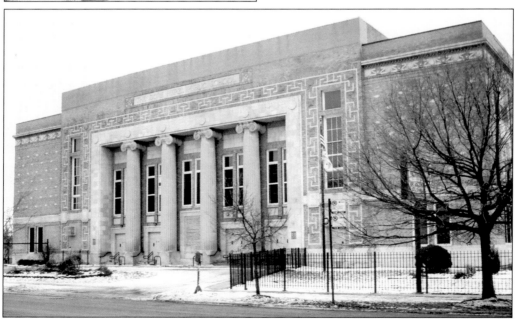

Theodore Herzl Junior College, located on Douglas Boulevard and Hamlin Avenue, is shown around 1940. The building was named after famed Zionist leader Theodore Herzl. It has also served as an elementary school and for the training of sailors during World War II. Many of the area high school graduates went there as it was a free city college.

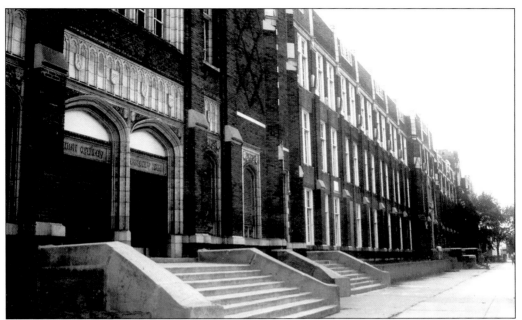

Hugh Manley High School opened in 1928 at 2935 Polk Street adjacent to Sacramento Boulevard. After John Marshall High School, it contained the second-largest enrollment of Jewish students. The school also had a sizable number of Italian students. In 1943, it was taken over by the navy and accommodated live-in sailors. After the war, it became a public high school once again.

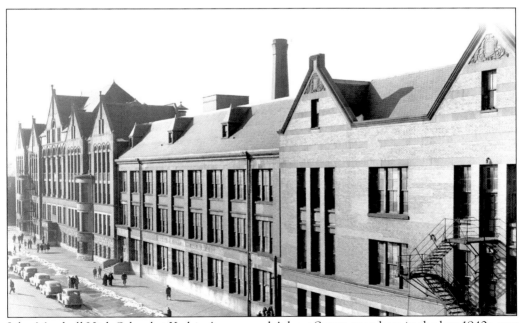

John Marshall High School at Kedzie Avenue and Adams Street, seen here in the late 1940s, was the high school most of the Jewish students of the area attended, and it was noted for its high academic achievement and winning basketball teams. (Courtesy of Sid Bass.)

Bryant Elementary School, located at Fourteenth Street and Kedvale Avenue, is pictured around 1980. It generally served most of the North Lawndale community from Pulaski Road westward to the city boundary with Cicero. The site is now vacant.

George Howland Elementary School is located at Sixteenth Street and Spaulding Avenue. During the warmer months, young Jewish men had baseball games in the schoolyard almost every late afternoon. One of its more prominent graduates is comedian Shelley Berman.

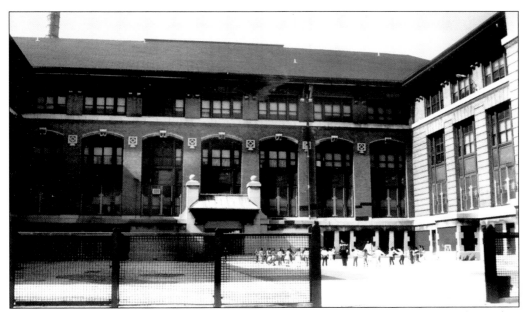

Students play in the schoolyard of William Penn Elementary School, which was located at 1600 South Avers Avenue, in 1989. The school changed in the 1945–1955 period from virtually all Jewish to all African American.

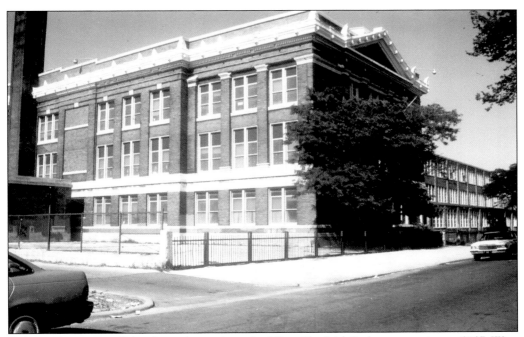

Delano Elementary School was located in the West Garfield Park community at 3937 West Wilcox Street. It was located next to an Associated Talmud Torah school that is now down. The school had a mixed student ethnic population.

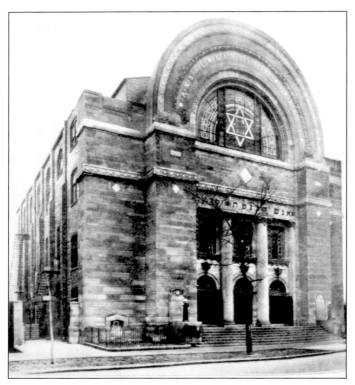

Anshe Kanesses Israel Synagogue, the Russische shul, was built in 1913 at 3411–3419 Douglas Boulevard. It came from the Maxwell Street area where it had been founded by Russian immigrants in 1875. It had the largest seating capacity of any of the city's synagogues, almost 3,500. It had 35 Torah scrolls, and for the High Holidays, it attracted some of the best cantors from eastern Europe. Many influential eastern European Jews were congregation members. Rabbi Ephraim Epstein (1876–1960) served as its rabbi for almost half a century.

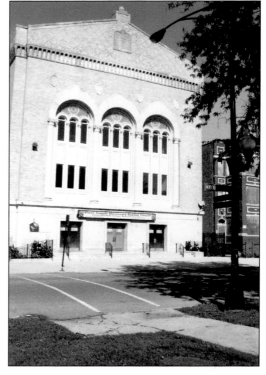

The First Romanian Congregation (Shaari Shomayim or Gates of Heaven) was founded by Romanian Jewish immigrants in the Maxwell Street area. After a number of different locations in that neighborhood, it relocated to 3622 Douglas Boulevard, where it soon became one of the largest and most active synagogues in Lawndale. A highlight in its history is when Queen Marie of Romania attended services at the synagogue on her visit to Chicago in 1926. It is now the Stone Temple Missionary Baptist Church.

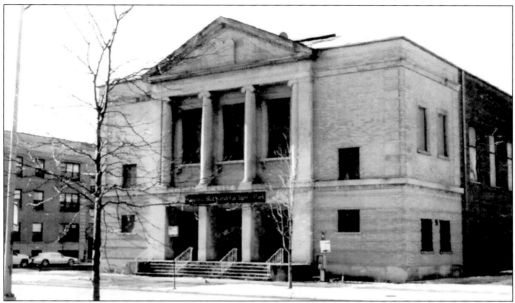

The former Anshe Sholom Congregation at Polk Street and Independence Boulevard is now the Independence Boulevard Seventh-Day Adventist Church. For 36 years, the synagogue was led by the renowned Rabbi Saul Silber and also had the well-known cantor Joshua Lind. The building has been little changed by the church, and many of the Jewish symbols still remain. (Courtesy of Robert Packer.)

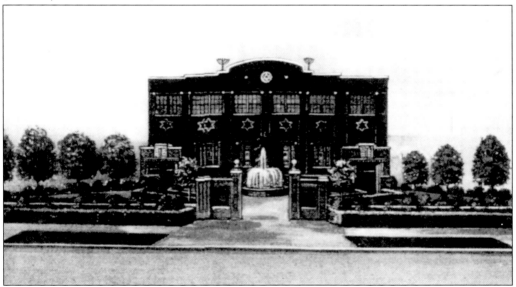

Temple Judea was organized in 1913, and a few years later, a temple was built at 1227 South Independence Boulevard inward from the street with attractive foliage, a fountain, and two large menorahs affixed to the roof. It was the only Reform temple in the immediate North Lawndale area and was viewed with some apprehension by the largely Orthodox community because of such practices as seating men and women together. The temple was noted especially for its lecture series and progressive youth organization. (Courtesy of Robert Packer.)

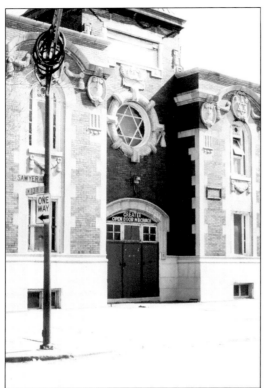

Shaarei Torah Anshe Maarov at 1301 South Sawyer Avenue was established in 1908 largely by Lithuanian immigrants and is considered to be the first synagogue in Lawndale. It was often called the "politician's shul" because many of the important politicians of the powerful 24th Ward Democratic Organization belonged there.

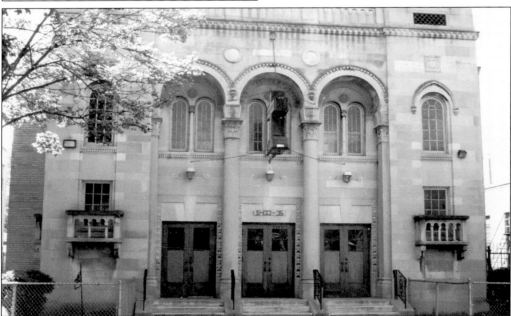

B'nai Israel at 5433 Jackson Boulevard was the largest synagogue in Austin. The Conservative synagogue's rabbi for many years was Shlomoh Z. Fineberg. The building now houses an African American church. (Courtesy of Robert Packer.)

# *Three*

# PEOPLE

There was no dominant ethnic group in the Lawndale area until the Jews started moving in around 1910. Until that time, there were several different ethnic groups who settled there after the Great Fire of 1871. The visibility of these various groups is shown by the churches built from 1880 to 1910. Among them were St. Ludmilla Church, Blessed Agnes Church, and Our Lady of Lourdes Church, all started by Bohemians (Czechs), and Our Lady of Sorrows Basilica, Blessed Sacrament Church, St. Agatha Church, and Presentation Church, started by the Irish.

Of these groups, the Irish mainly to the north and especially the Bohemians mainly to the south were the largest. Besides their churches, the Bohemians also had the Bohemian Club on Douglas Boulevard, a number of *sokols* (gymnastic and fraternal organizations), and a Czech Freethinkers school. Twenty-sixth Street was the city's main Bohemian shopping street. Along the street near Kedzie Avenue was Pilsen Park, where many picnics and other events were held.

Although the Bohemian area persisted for a few more decades, the area to the north of Ogden Avenue started becoming Jewish around 1910. Despite opposition, the Jews continued to buy homes, and by 1925, the community known as North Lawndale was almost all Jewish.

The Jews who moved into North Lawndale came largely from the Maxwell Street area. While the Maxwell Street Jews were almost a direct transplant of the poor eastern European Jews and lived somewhat similarly, the Jews of North Lawndale lived in pleasant physical surroundings and were working hard to achieve middle-class status. Despite the hardships caused by the Great Depression when some lost their jobs and homes, upward mobility continued. Old World cultural patterns and traditions were slowly modified. This was true among some of the more radical, irreligious Jews and especially among the younger American-born Jews. Despite some prejudice and restrictions, more opportunities existed for Jewish youth in Chicago than ever before, and many who lived in North Lawndale for a while became prominent, including Benny Goodman, Ald. Jacob Arvey, Golda Meir, Shelley Berman, Irv "Kup" Kupcinet, Rabbi Saul Silber, Judge Abraham Lincoln Marovitz, Eli Shulman, Meyer Levin, and Elmer Gertz.

North Lawndale was a mixture of the new and the old, but some Yiddishkeit was always prevalent as was respect for Jewish values and causes. Wherever one turned, one heard Yiddish spoken and was within sight of a kosher butcher shop or a synagogue. It was not Maxwell Street, but it was still very Jewish.

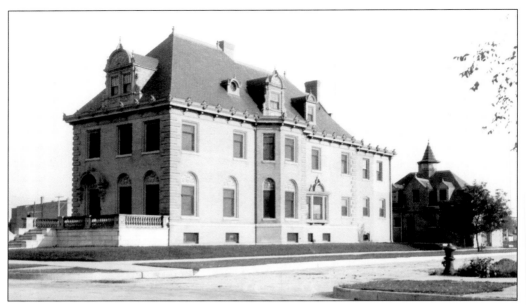

The former mansion of Republican congressman and senator William Lorimer, located at 3659 West Douglas Boulevard, is seen here. He was expelled from the Senate in 1912 when it was proven that he bribed his way into that body. The building later became the Ceska Beseda (Bohemian Club), which was visited by such well-known people of Bohemian descent as composer Rudolf Friml, coach George Halas, and Gov. Otto Kerner. (Courtesy of the Chicago History Museum.)

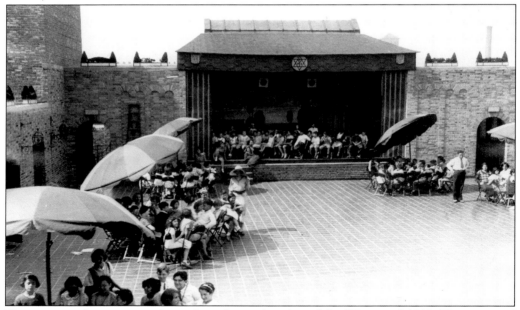

This summer day camp was located on the roof garden of the JPI around 1940. This is one of the numerous educational, social, cultural, and athletic activities at the JPI. The roof garden also hosted Sunday evening dances in the summer. (Courtesy of the Jewish Community Centers of Chicago.)

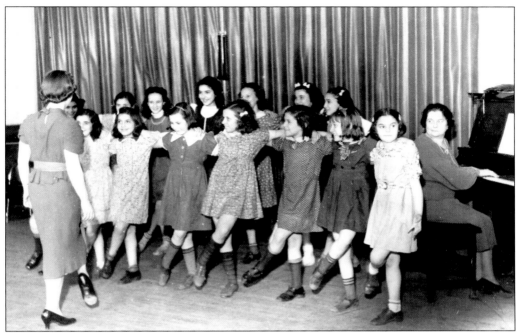

A young girls' dancing class takes place at the JPI, which was located in the heart of Lawndale on Douglas Boulevard and St. Louis Avenue. The institute had a great variety of activities for young people.

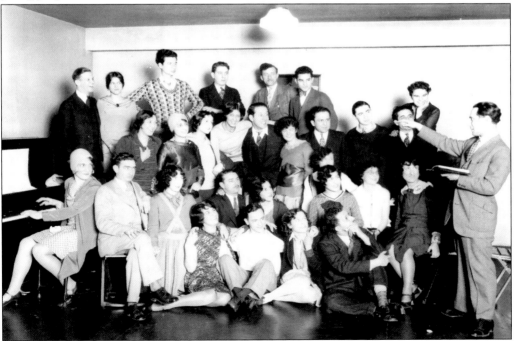

A choir practices at the JPI around 1930. Some 70 different organizations and clubs met at the JPI in 1932. In 1979, the JPI was made a national historic landmark.

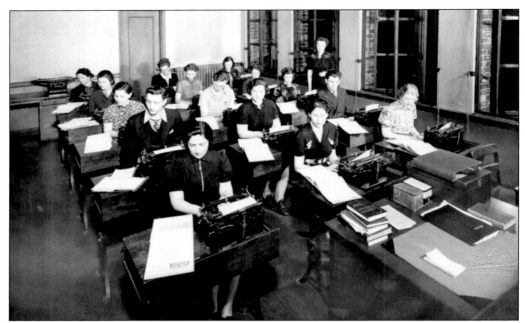

An adult evening commercial class was held at the JPI in the 1930s. Through the years, the JPI offered a variety of adult education classes as well as numerous lectures, concerts, and plays. Before most families had automobiles, people used the local community facilities extensively. (Courtesy of the Chicago History Museum.)

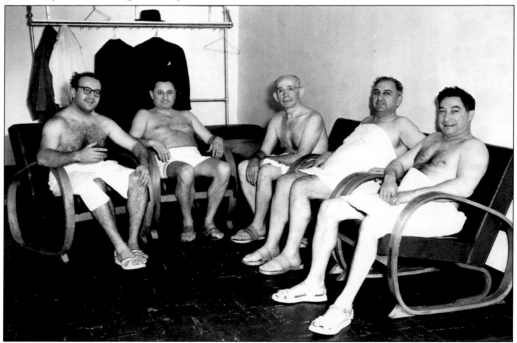

Jewish men are cooling off and relaxing after being in the pool at the Jewish JPI around 1940. (Courtesy of the Jewish Community Centers of Chicago.)

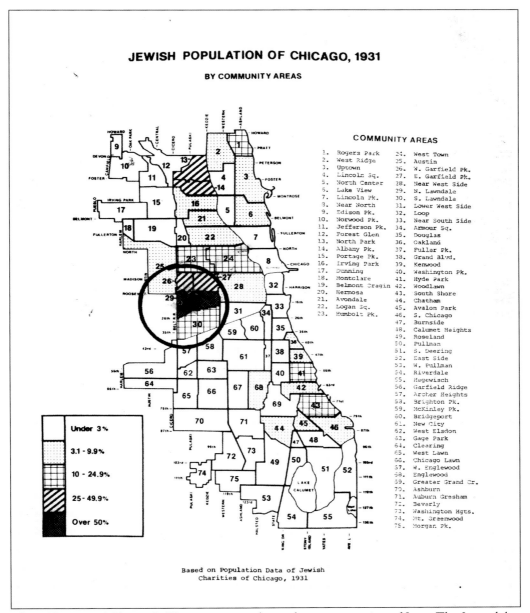

# JEWISH POPULATION OF CHICAGO, 1931

### BY COMMUNITY AREAS

**COMMUNITY AREAS**

| | | | |
|---|---|---|---|
| 1. | Rogers Park | 24. | West Town |
| 2. | West Ridge | 25. | Austin |
| 3. | Uptown | 26. | W. Garfield Pk. |
| 4. | Lincoln Sq. | 27. | E. Garfield Pk. |
| 5. | North Center | 28. | Near West Side |
| 6. | Lake View | 29. | N. Lawndale |
| 7. | Lincoln Pk. | 30. | S. Lawndale |
| 8. | Near North | 31. | Lower West Side |
| 9. | Edison Pk. | 32. | Loop |
| 10. | Norwood Pk. | 33. | Near South Side |
| 11. | Jefferson Pk. | 34. | Armour Sq. |
| 12. | Forest Glen | 35. | Douglas |
| 13. | North Park | 36. | Oakland |
| 14. | Albany Pk. | 37. | Fuller Pk. |
| 15. | Portage Pk. | 38. | Grand Blvd. |
| 16. | Irving Park | 39. | Kenwood |
| 17. | Dunning | 40. | Washington Pk. |
| 18. | Montclare | 41. | Hyde Park |
| 19. | Belmont Cragin | 42. | Woodlawn |
| 20. | Hermosa | 43. | South Shore |
| 21. | Avondale | 44. | Chatham |
| 22. | Logan Sq. | 45. | Avalon Park |
| 23. | Humbolt Pk. | 46. | S. Chicago |
| | | 47. | Burnside |
| | | 48. | Calumet Heights |
| | | 49. | Roseland |
| | | 50. | Pullman |
| | | 51. | S. Deering |
| | | 52. | East Side |
| | | 53. | W. Pullman |
| | | 54. | Riverdale |
| | | 55. | Hegewisch |
| | | 56. | Garfield Ridge |
| | | 57. | Archer Heights |
| | | 58. | Brighton Pk. |
| | | 59. | McKinley Pk. |
| | | 60. | Bridgeport |
| | | 61. | New City |
| | | 62. | West Elsdon |
| | | 63. | Gage Park |
| | | 64. | Clearing |
| | | 65. | West Lawn |
| | | 66. | Chicago Lawn |
| | | 67. | W. Englewood |
| | | 68. | Englewood |
| | | 69. | Greater Grand Cr. |
| | | 70. | Ashburn |
| | | 71. | Auburn Gresham |
| | | 72. | Beverly |
| | | 73. | Washington Hgts. |
| | | 74. | Mt. Greenwood |
| | | 75. | Morgan Pk. |

| | |
|---|---|
| Under 3% | |
| 3.1 - 9.9% | |
| 10 - 24.9% | |
| 25 - 49.9% | |
| Over 50% | |

Based on Population Data of Jewish
Charities of Chicago, 1931

This 1931 map of Chicago's 75 communities shows the concentration of Jews. The Lawndale–Garfield Park area at that time had over 110,000 of the almost 300,000 Jews in the entire metropolitan area. Of the total, over 45 percent of the Jews of that area were foreign born with 78 percent coming from the former Russian Empire. (Courtesy of the Jewish Charities of Chicago.)

The auditorium of the JPI, where many theater, orchestra, class, and lecture events were held, is seen here. It is now the auditorium of the Lawndale Academy, a public elementary school. (Courtesy of Robert Packer.)

Sabbath religious services are held at the Orthodox Jewish Home for the Aged, which was located at Ogden Avenue and Albany Avenue. The men and women sat separately. The block-long home directly opposite Douglas Park opened in 1903 and closed during the turbulent years of the late 1960s.

Residents of the Orthodox Jewish Home for the Aged celebrate the holiday of Sukkoth, the Feast of the Tabernacles or also known as the festival of the harvest, in 1932. It is customary during the seven-day holiday to have meals in a sukkah, a simple tentlike structure with a roof made of leafy boughs or straw. The man is shown holding a *lulav*—usually a young palm branch. (Courtesy of the Chicago History Museum.)

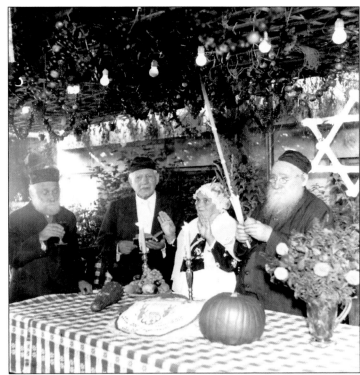

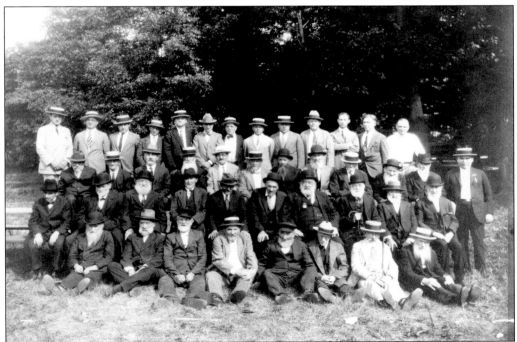

Male residents of the Orthodox Jewish Home for the Aged are seen around 1930. A Jewish philanthropist from Iowa, Abraham Slimmer, provided substantial seed money for the building.

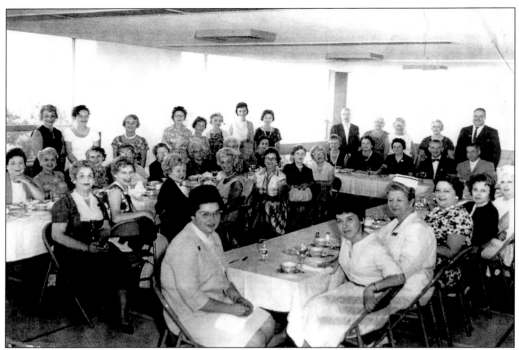

This luncheon for volunteers was held in 1925 at the Orthodox Jewish Home for the Aged. The home served elderly men and women for more than half a century.

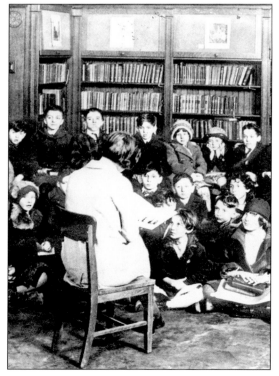

Story time at the Legler Public Library, located at 115 South Crawford Avenue (now Pulaski Road), is pictured around 1930. Legler was the largest library in the area.

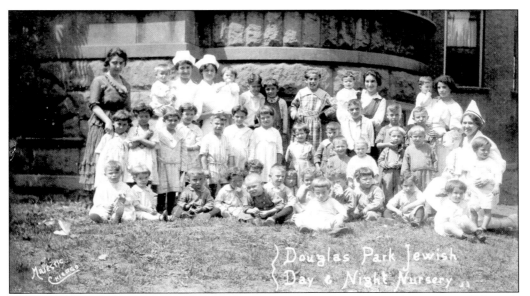

The Douglas Park Jewish Day and Night Nursery was located on Albany Avenue near Fifteenth Street opposite Douglas Park. It was one of four major Jewish institutions that were aligned one after the other on Albany Avenue. The other homes were the Jewish People's Convalescent Home, the Marks Nathan Jewish Orphan Home, and the Orthodox Jewish Home for the Aged. Only the orphanage building is still standing and serves as a Catholic senior citizens' home. (Courtesy of the Chicago History Museum.)

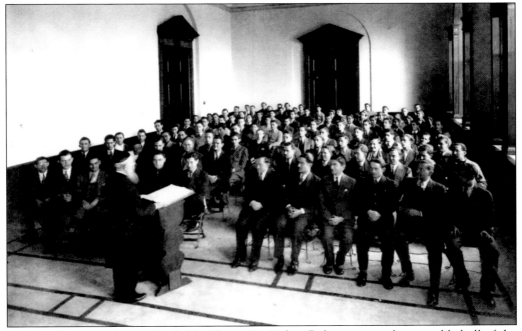

Students listen to a lecture by Rabbi Chaim Zvi Halevi Rubenstein in the assembly hall of the Hebrew Theological College in Lawndale in 1942. Some of the students later became prominent Orthodox rabbis. (Courtesy of the Hebrew Theological College.)

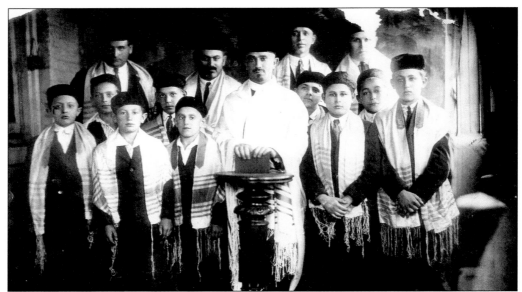

The High Holiday male choir is pictured here at the Kehilath Jacob Congregation, which was located at Douglas Boulevard and Hamlin Avenue, in 1930. Like many of the other synagogues in Lawndale, the congregation started in the Maxwell Street area, where its last home was on Center (Racine) Avenue and Taylor Street. Most of its original members came from Drohitchin, Russia. Near the synagogue was a three-story Hebrew school. (Courtesy of the Chicago Jewish Archives.)

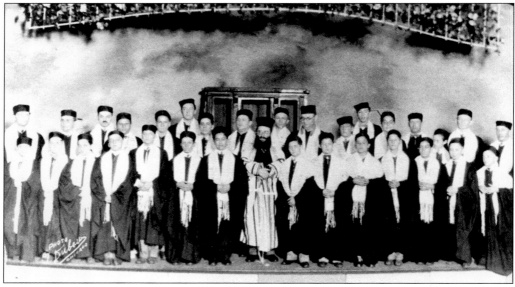

Famed Cantor Yossele Rosenblatt (1882–1933) was born in a Ukrainian shtetl (small village). At the age of 18, he became the cantor of an Orthodox Hungarian synagogue. He came to the United States in 1911 and soon gained success as probably the best cantor of his day. He also was a prolific composer and once turned down a lucrative offer to sing in the opera. Here he is shown (front center) with the choir at the Knesses Israel Nusach Sfard synagogue in North Lawndale around 1929. (Courtesy of Pearl Hirshfield.)

The faculty of the Orthodox Chicago Jewish Academy, located at Wilcox Street and Pulaski Road, is seen here in the late 1940s. (Courtesy of Robert Packer.)

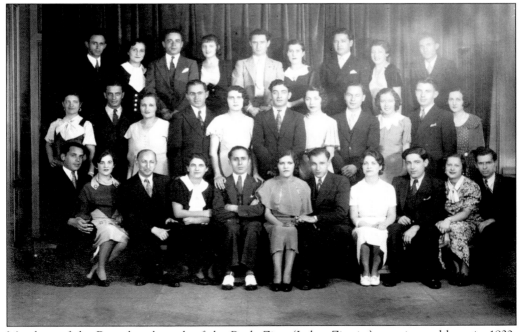

Members of the Borochov branch of the Poale Zion (Labor Zionist) are pictured here in 1932. Most of their meetings were held at 3322 West Douglas Boulevard in North Lawndale. Some of the members later settled in Israel.

# HABONIM

## WE KNOW HOW OUR BOY AND GIRL SPEND THEIR TIME !

They spend it in a progressive Jewish environment.

They learn about Jewish life and culture.

They are inspired by Labor Palestine, the Chalutzim.

They enjoy Jewish songs and folk dances.

They celebrate Jewish national holidays.

They become acquainted with social and economic problems.

They develop their bodies and minds.

### THEY BELONG TO HABONIM

the most advanced and appealing organization for Jewish boys and girls. Habonim has been admired by scores of educators, community center workers, and other leaders of youth as a vital, constructive force in Jewish life.

IF you want your child to love the finest and best in Jewish life;
IF you want your child to grow up to be an intelligent and active Jew;
IF you want your child to have a balanced cultural and physical life —
### BRING YOUR CHILD TO US.

HABONIM is an organization for boys and girls between the ages of 10 and 18. HABONIM carries on many activities such as discussions; celebrations; camping; Zionist work; etc. HABONIM publihes the outstanding children's magazine, HABONEH.
### EVERY JEWISH CHILD HAS A PLACE IN HABONIM.

---

### WHAT DOES YOUR CHILD READ ?

If you found a stimulating, educating, entertaining magazine for JEWISH CHILDREN could you afford not to place it in the hands of your boy and girl ?

# HABONEH

### (The Builder)

### A MONTHLY MAGAZINE FOR THE GROWING JEWISH BOY AND GIRL IN AMERICA

In the language of children and youth, "HABONEH" tells the story of Pioneering Palestine;    of world Jews;    of Jewish folk lore.

Only $1.00 a year.          (Published Monthly except July and August).

---

### For further information, inquire:
## HABONIM 3322 Douglas Boulevard

This c. 1940 recruitment circular is for Habonim, the youth group of the Labor Zionists, who met in the Labor Zionist building. (Courtesy of the Chicago Jewish Archives.)

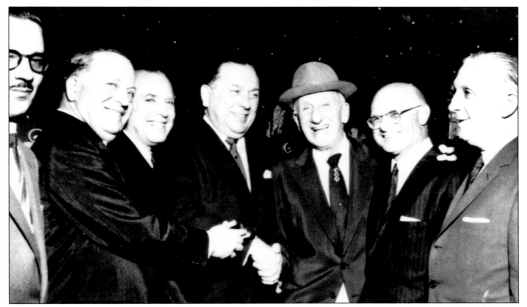

The powerful political figures of the 24th Ward Democratic Organization are at a preelection rally held at the Theodore Herzl Junior College around 1948. To attract a large audience, a celebrity was often brought in for these events. Pictured are, from left to right, Arthur Schimmel, Arthur Elrod, Judge Abraham Lincoln Marovitz, Mayor Richard J. Daley, Jimmy Durante, Ald. Jacob Arvey, and Sidney Deutsch.

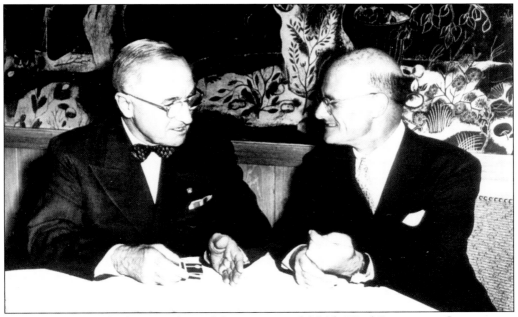

Ald. Jacob Arvey, the longtime boss of the very powerful 24th Ward Democratic Organization of Lawndale, is shown here with his friend Pres. Harry S. Truman. Arvey is believed to have used his position to convince the president to recognize the State of Israel in 1948. Through the years, Arvey was involved in many Jewish causes both at home and abroad.

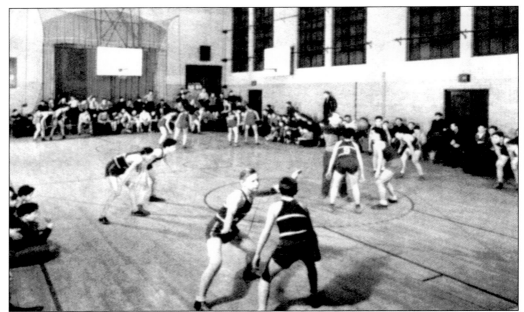

A basketball game is played at the ABC in 1937. The facility was located at 3415 West Thirteenth Place and run by the Young Men's Jewish Council. The facility served over 50,000 boys in the Lawndale community from 1930 to 1955 who participated in such activities as athletics, crafts, and debating.

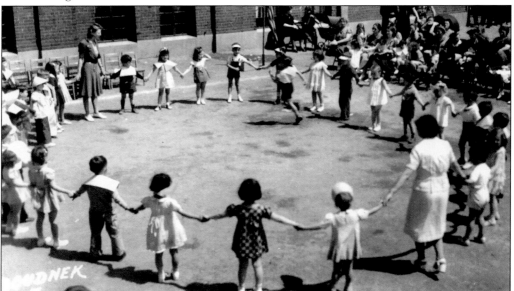

Children play at Marcy Center's playground located on Avers Avenue near Sixteenth Street with adults looking on around 1940. The youth center was run by a church group, but its many activities attracted Jewish children, who used its athletic facilities, watched its movies, and ate candy there at Christmastime. Marcy Center had previously been in the Maxwell Street area. (Courtesy of the Richard J. Daley Special Collections Department at the University of Illinois at Chicago.)

Transportation for the young was often provided by homemade scooters constructed out of apple or orange crates with a split roller skate at the bottom and with pop caps as ornamentation. (Courtesy of the Richard J. Daley Special Collections Department at the University of Illinois at Chicago.)

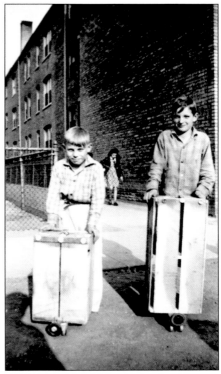

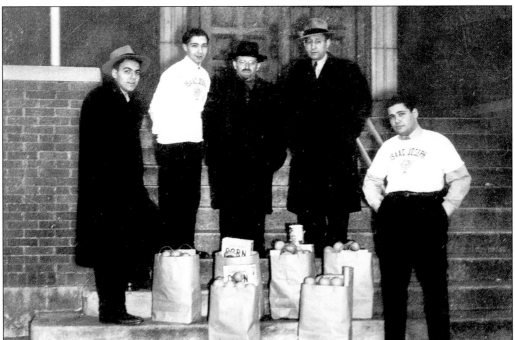

Isaac Joseph AZA members and others prepare to deliver food for donations to needy families. AZA is the male youth group of B'nai B'rith. (Courtesy of Judy Harris.)

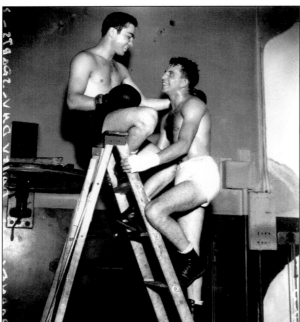

Barney Ross (left) was a world's lightweight, junior welterweight, and welterweight boxing champion and a World War II war hero. He and his friend lightweight contender Davey Day would often frequent Davy Miller's pool hall, boxing gymnasium, gambling, and restaurant complex on Roosevelt Road near Kedzie Avenue in North Lawndale. (Courtesy of the Chicago History Museum.)

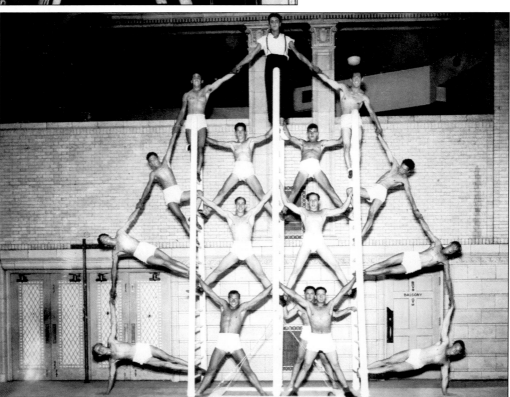

Male gymnasts perform in the Douglas Park field house around 1937. Gymnastics was one of many activities in the field house. (Courtesy of the Chicago Park District.)

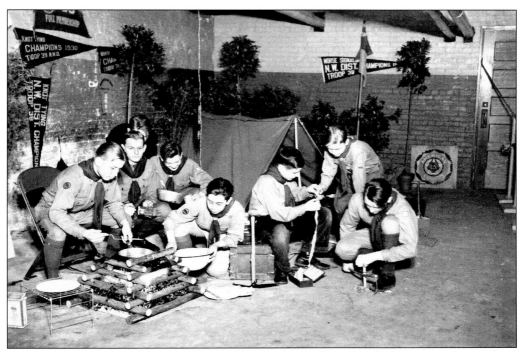

A Boy Scout troop in the Douglas Park field house learns the ways of surviving in the outdoors around 1937. (Courtesy of the Chicago Park District.)

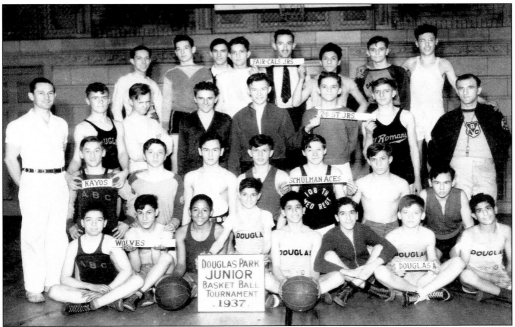

This photograph in the gymnasium of the Douglas Park field house shows the players and team names of the participants in the 1937 basketball tournament. (Courtesy of the Chicago Park District.)

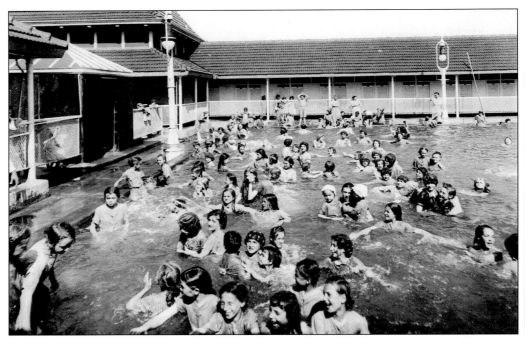

It was girls' day in the outdoor swimming pool in Douglas Park when this photograph was taken in 1914. Built in the late 1890s, the Douglas Park pool was the first outdoor natatorium in the Chicago parks. (Courtesy of the Chicago Park District.)

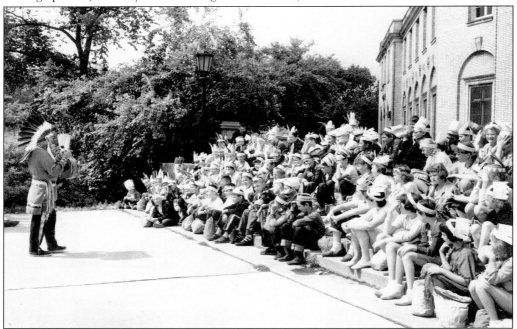

Chief Whirling Thunder teaches Native American lore to the Garfield Park summer day camp attendees in 1956. The chief taught his subject for a number of decades in many of the city's parks. (Courtesy of the Chicago Park District.)

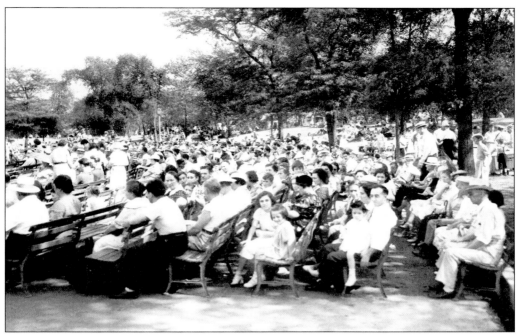

An outdoor band plays a concert at Garfield Park on August 8, 1937. During the warm months, band concerts were sometimes given on weekends in the larger parks. (Courtesy of the Chicago Park District.)

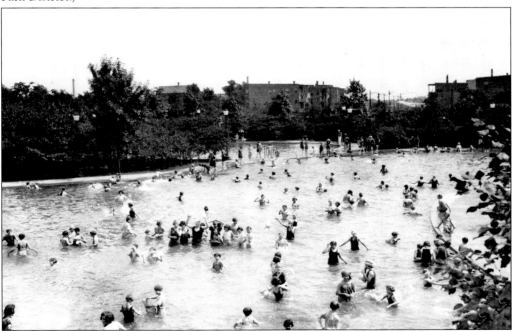

Residents enjoy swimming at Franklin Park in the western part of North Lawndale in 1921. In the foreground is the shallow swimming pool, and in the background is the deeper pool. (Courtesy of the Chicago Park District.)

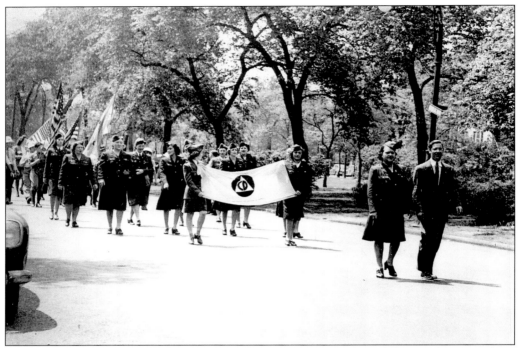

Jennie Greenberg and Arthur Schimmel lead a parade of civilian defense volunteers along Douglas Boulevard in 1944 during World War II. (Courtesy of Debra M. Greenberg.)

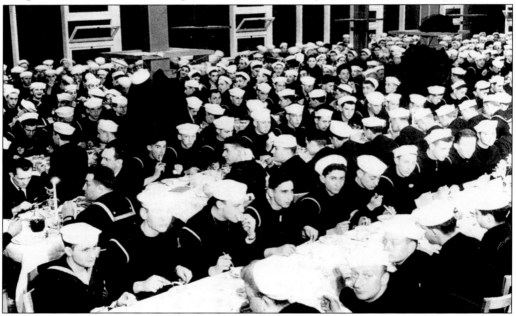

Many Jewish men and women served in the navy in World War II. This is a Passover seder at the Great Lakes Naval Training Station located in north Chicago in 1943. The seder was organized by chaplain Julius Mark and Clarissa Schwartz of Waukegan. (Courtesy of the Jewish Federation of Metropolitan Chicago.)

Irv "Kup" Kupcinet (1912–2003) lived on Sixteenth Street near Kedzie Avenue in North Lawndale. After a short professional football career with the Philadelphia Eagles, he became a sportswriter and announcer, a pioneer television talk show host, and, for more than half a century, a celebrity and political gossip columnist for the *Chicago Sun-Times*. He won numerous awards during his career. This statue is along the Chicago River on Wacker Drive opposite the Chicago Sun-Times Building.

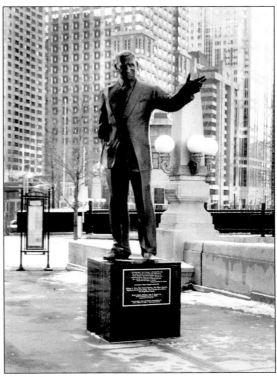

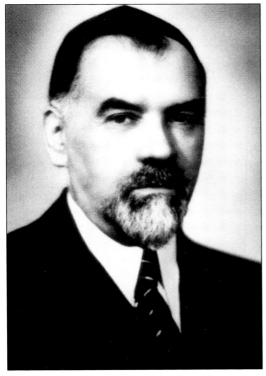

Rabbi Saul Silber (1881–1946) was a founder of the Hebrew Theological College and was its president from 1922 to his death. He served as rabbi of the large Anshe Sholom Congregation for 36 years, was very active in many Jewish organizations, and was a leader in the Zionist movement. (Courtesy of Michele Vishny.)

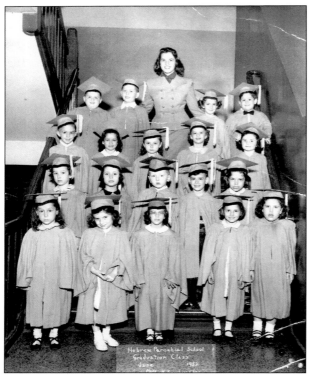

The 1952 graduating class of the Hebrew parochial school located at the JPI poses here for a photograph. It was one of the dozens of programs and activities at the JPI. (Courtesy of Davina Packer Segal and Robert Packer.)

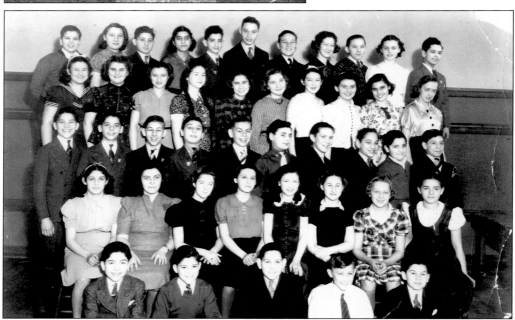

Pictured is the February 1938 class of Bryant Elementary School, located at Fourteenth Street and Kedvale Avenue. The majority of its students were Jewish. The school was demolished in the 1980s and the land remains vacant. The school generally served the children who lived west of Crawford Avenue (now Pulaski Road). (Courtesy of Shirley Tobias.)

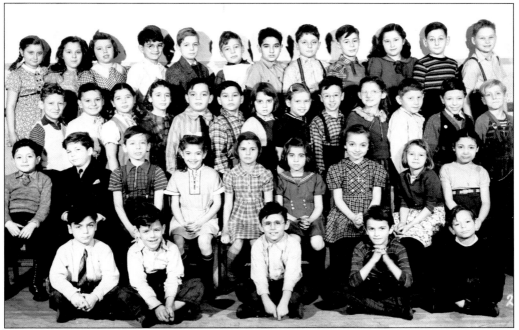

The Victor Lawson Elementary School 3B class had this picture taken in December 1940. Lawson was located at 1256 South Homan Avenue. The vast majority of the students were Jewish with the remainder being mainly of Italian descent. (Courtesy of Sherwin Schwartz.)

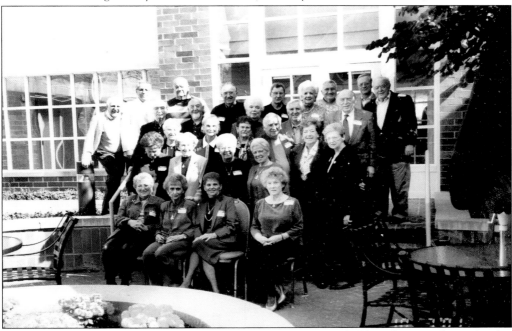

The reunion of the January 1941 Lawson graduating class was held at the Wyndham Garden Hotel on September 24, 2001, in Buffalo Grove. Virtually all the attendees were Jewish. (Courtesy of Zelda Bachrach.)

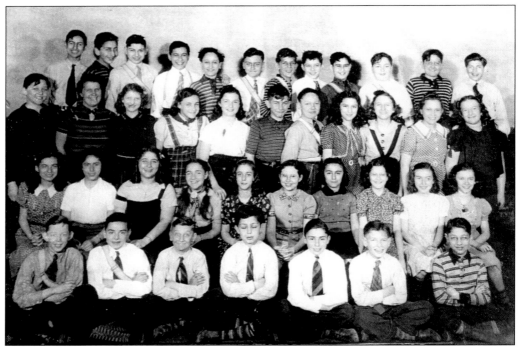

The 1939 7A class of William Penn Elementary School, which was located at Sixteenth Street and Hamlin Avenue in Lawndale, poses for a photograph.

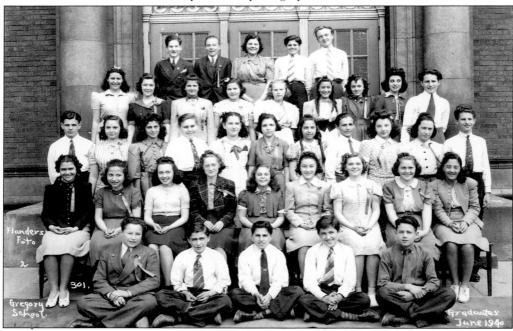

Seen here is the June 1940 graduating class of Gregory Elementary School. The school is located at Polk Street and Lawndale Avenue just west of what used to be the huge Sears, Roebuck and Company complex.

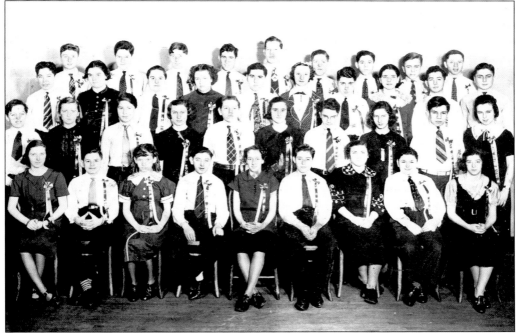

This is the June 1936 eighth-grade graduating class of George Howland Elementary School, which was located at Sixteenth Street and Spaulding Avenue. The school was built in 1893 with additions in 1913 and 1924. Upon graduation, most of the students went to either John Marshall High School or Hugh Manley High School.

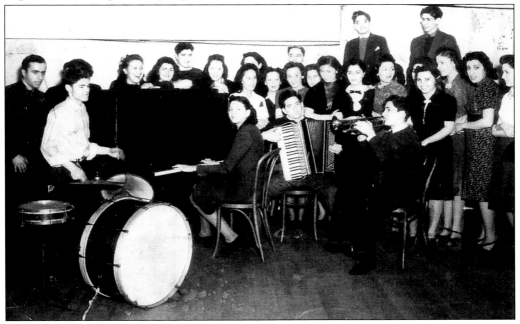

Pictured is the orchestra at Hugh Manley High School, located at Sacramento Boulevard and Polk Street, in 1940. (Courtesy of Pearl Hirshfield.)

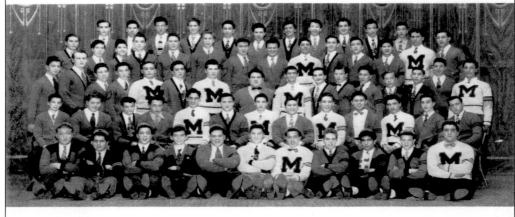

# MARSHALL "M" CLUB

Seated:    Rencler, Gerber, DeKoven, Bryant, Cohen, Lance, Bemorso, Portnoy, Haskell, Brown, Weiss.
Row I     Perlman, Podell, Levy, Rosen, Broude, Freedkin, Zweig, Pinsky, Harris, Lipsky, Isenstein, Sherman, Lieberman.
Row II    Winer, Delre, Mendelssohn, Berman, Singer, Kaufman, Siegel, Chiero, Sax, Wieselman, Conner, Phillips, Becker, Blick, Wilens, Marks.
Row III   Oster, Chinskey, Dubow, Arons, Rabin, Finkel, Kaufman, Fleishman, Moio, Schiffman, Reizman, Artslem, Viner, Fox.
Row IV    Weinberg, Chenskey, Schwartz, Batko, Kaufman, Friedman, Kolton, Rabinovitz, Hansfield, Landerman, Bass.

These boys were members of the John Marshall High School M Club from 1945 to 1946. M Club members were students who usually had performed well enough in athletics to earn a letter. (Courtesy of Sherwin Schwartz.)

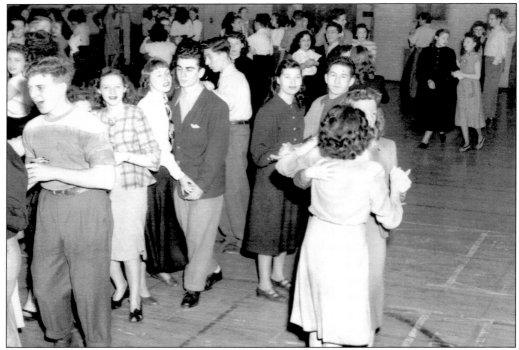

A social dance at John Marshall High School, located at 3250 West Adams Street, is seen here in 1947. The school was named after the longtime 19th-century chief justice of the U.S. Supreme Court. (Courtesy of Sid Bass.)

# *Four*

# COMMERCE, INDUSTRY, AND LABOR

Some large companies were attracted to the West Side in the years after the 1871 fire, including some that had been burned out. The vast stretches of vacant prairie, the proximity of railroads, and the spreading of transit lines made the area appealing to a number of very large companies. The Western Electric Company at its peak employed over 40,000 workers; Sears, Roebuck and Company employed about 10,000; and thousands worked in other plants. Many of the early local residents, including the Bohemians, Irish, Poles, Germans, and Slovaks, worked in many of these plants. However, very few Jews who started moving into North Lawndale and its vicinity about 1910 worked for these companies with the exception of Sears, Roebuck and Company, where many worked, especially in the company offices.

Many Jewish workers were employed downtown by the garment industry, often working for German Jewish–owned companies such as Hart, Schaffner and Marx and Kuppenheimer and Company and for smaller clothing manufacturers. Jews were also employed by downtown department stores and in some offices. Some worked in local stores, on Maxwell Street, and in the South Water Street Produce Market, while others were produce peddlers in ethnic neighborhoods, traversing alleys and streets first with horses and wagons and later with small trucks.

Jews also worked in a variety of crafts such as painting, carpentry, baking, butchery, and laundry. Some were in the professions and served as religious workers, pharmacists, teachers, dentists, doctors, and lawyers. A large number were small merchants owning food, clothing, shoe, furniture, tailor, and other types of consumer stores in many parts of the city. Jewish workers were generally ardent union members and leaders, including belonging to about 28 Jewish-only unions.

In the North Lawndale area, with the exception of a few dime and shoe chain stores, most of the stores were owned by Jews. The people of the community could find everything they needed nearby. Roosevelt Road, the main commercial street, had for almost two miles a virtual unbroken array of stores, entertainment facilities, and professional offices. A street map from about 1930 shows that along this stretch, among other stores, were 26 restaurants, 4 bookstores, 7 bakeries, and 12 butcher shops. Not shown were three gambling places.

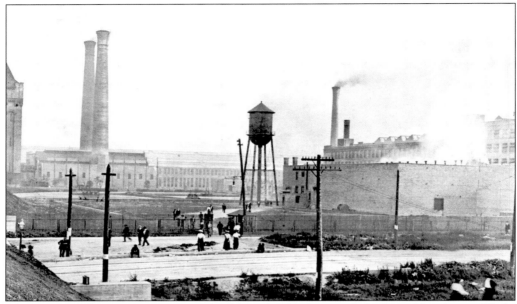

The Western Electric Company, a subsidiary of AT&T, opened the huge Hawthorne Works plant at Cermak Road and Cicero Avenue in 1904. By 1917, the plant employed 25,000 people, many of Czech or Polish descent. By the 1920s, the company supplied about 90 percent of all the telephone equipment used in the country. During the World War II period, the plant employed almost 50,000 people. The plant closed in 1984 after AT&T was broken up.

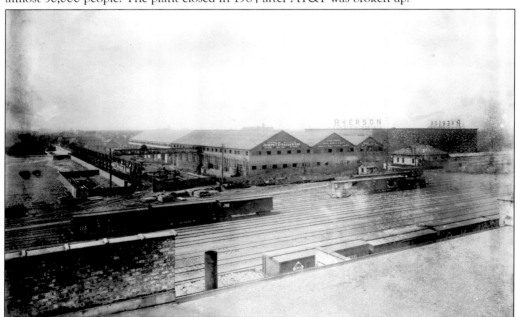

The Ryerson Steel plant, seen around 1908, was located in the vicinity of Sixteenth Street and Western Avenue on the fringe of Lawndale, where some of its employees lived. It became one of the leading wholesalers and processors of steel products. (Courtesy of the Chicago History Museum.)

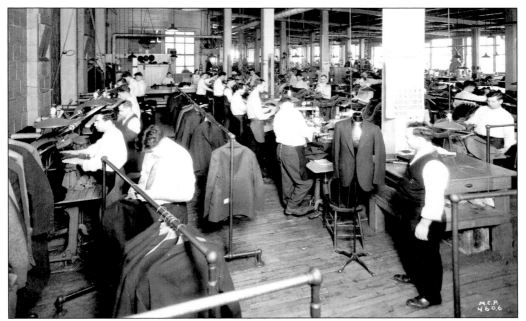

Male workers are pictured at the German Jewish–owned Hart, Schaffner and Marx men's clothing factory, which included many Jews from the West Side, in 1930. The workers belonged to the progressive Amalgamated Clothing Workers of America union, of which Sidney Hillman, a Lithuanian Jewish immigrant, was president for 30 years.

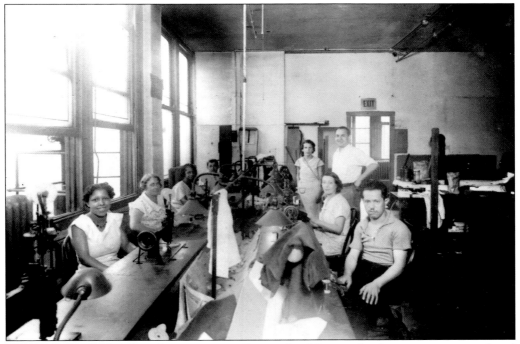

The Acme Art Embroidery Company, a small specialized firm in the downtown area, employed many workers from the Lawndale area. Work at this company was often seasonal.

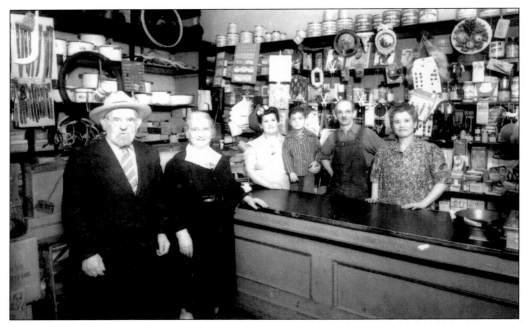

The Hirshfield hardware store was located on Roosevelt Road one and a half blocks west of Crawford Avenue around 1941. In the foreground are, from left to right, Ida Hirshfield's parents, Joseph and Frieda Plofsky, and owners Ida and David Hirshfield with their nephew Sandy Sher between them and sister Minnie Sher on the right. (Courtesy of Myrna Siegel.)

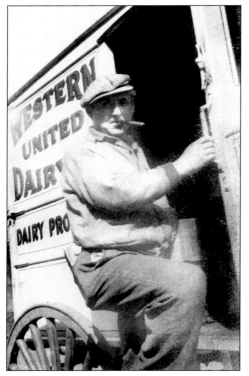

This Western United milkman delivered milk daily by horse and wagon to customers in the Lawndale area. The horse was so well trained that he automatically knew where to stop next. Almost from dawn to dusk, peddlers were common sights in the Jewish West Side, hawking their products as they proceeded through the neighborhood alleys. They would shout out their products, usually fresh fruits and vegetables, and the housewives would come rushing out of their homes to make their purchases. (Courtesy of Zelda Bachrach.)

Many of the people of Lawndale worked in the clothing industry, in and around downtown, with most belonging to unions. This poster in English and Yiddish tells of an emergency union meeting to be held at the Labor Lyceum in Lawndale in 1926. Some Jewish unions were organized when hostility was experienced in the general unions because of religious or cultural differences.

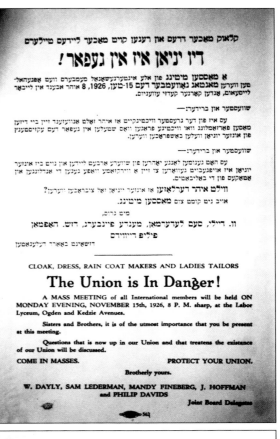

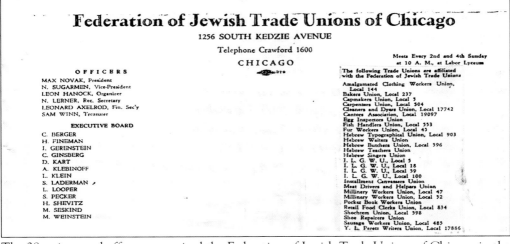

The 28 unions and officers comprised the Federation of Jewish Trade Unions of Chicago in the 1930s. The union headquarters was in the Jewish Daily Forward Building, and meetings were held at the Labor Lyceum, both buildings being on Kedzie Avenue in North Lawndale. These Jewish unions ranged from the carpenters' union to the *shochtem* (ritual slaughterers) union. (Courtesy of the Chicago Jewish Archives.)

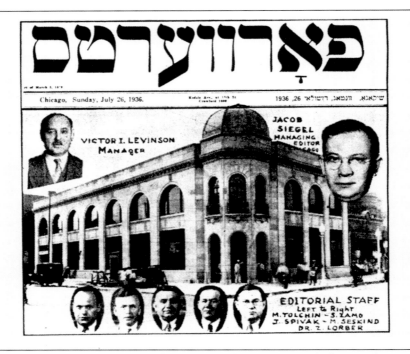

The Jewish Daily Forward Building was located at Kedzie Avenue and Thirteenth Street. Shown is the staff in 1936. Originally a branch of the *Jewish Daily Forward* of New York, the Chicago edition served the Yiddish-speaking immigrants from 1920 to 1953 with a peak circulation of about 15,000. Unlike the competing Orthodox *Daily Jewish Courier*, the *Forward* spoke more for the socialist-inclined immigrants, the Workmen's Circle members, the unions, and the secular Jews. (Courtesy of the American Jewish Historical Society.)

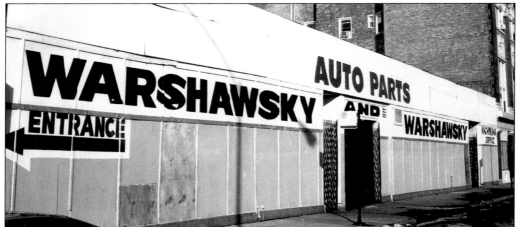

Warshawsky and Warshawsky was a large and well-known automotive parts company located on Ogden Avenue near Kedzie Avenue. In the background is the Labor Lyceum. Ogden Avenue (Route 66) was a major thoroughfare with numerous motor vehicle facilities, including the Emil Denemark Cadillac showroom. The showroom also had a radio station with the call letters WEDC standing for the automobile company. The station featured many ethnic language programs, including a number of Yiddish programs. One could stand outside and view the broadcast.

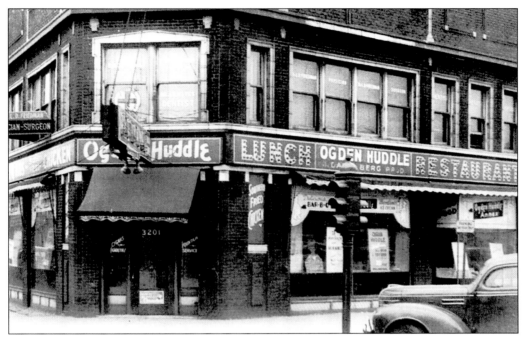

Eli Shulman, a Lawndale resident, started out with a restaurant, the Ogden Huddle, on the corner of Ogden and Kedzie Avenues opposite the Douglas Park Auditorium. During World War II, he often gave free meals to servicemen. (Courtesy of Mark Shulman.)

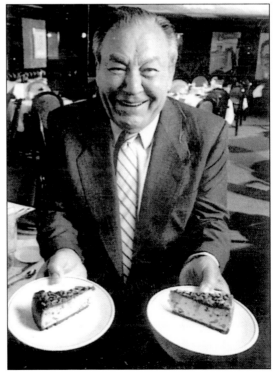

Eli Shulman is seen with one of his dozens of varieties of Eli's Cheesecakes. After starting out with the Ogden Huddle restaurant in Lawndale, he later opened the very popular Eli's the Place for Steak in the vicinity of Chicago and Michigan Avenues. It was there he developed for dessert a popular cheesecake. His famous cheesecake is now sold worldwide and has consistently been a leading seller at the Taste of Chicago. (Courtesy of Mark Shulman.)

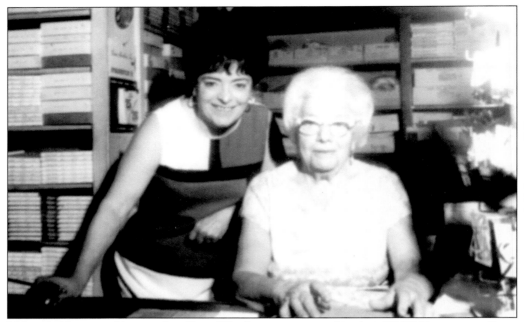

Helen Goldstein and her mother, Dina Weinberg, are pictured in their W. W. Department Store on the corner of Sixteenth Street and St. Louis Avenue. It was one of two small department stores on Sixteenth Street, the other being the Wallace Department Store. (Courtesy of Sandy Aronson.)

Sam Wallace and son Alan are pictured here by his Wallace Department Store, which was located at Sixteenth Street and Hamlin Avenue, in 1931. His business was wiped out by the riots of the 1960s. (Courtesy of Sherwin Schwartz.)

This photograph was taken inside Factors Kosher Butcher Shop, located at 3610 West Fifteenth Street, around 1948. The greater Lawndale area had dozens of kosher butcher shops during the time that most families kept kosher. Rolls of brown wrapping paper, chickens hanging from hooks, and sawdust on the floor were usually part of the decor.

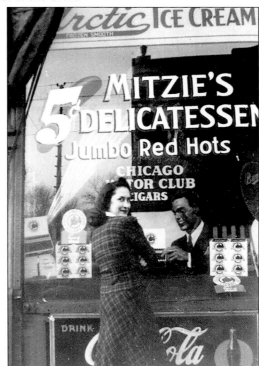

Mitzie Pozen's parents' delicatessen was located on Sixteenth Street and Harding Avenue. Shown in the photograph is her Hugh Manley High School classmate Pearl Belly (later Hirshfield). (Courtesy of Miriam Pozen and Pearl Hirshfield.)

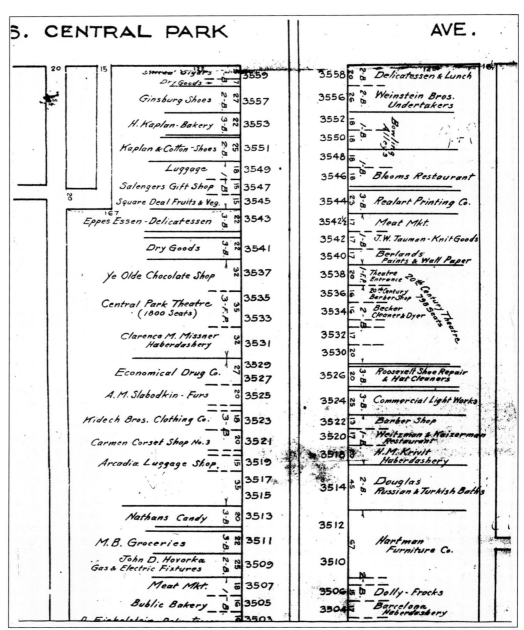

| | |
|---|---|
| Dry Goods | 3559 |
| Ginsburg Shoes | 3557 |
| H. Kaplan-Bakery | 3553 |
| Kaplan & Cotton - Shoes | 3551 |
| Luggage | 3549 |
| Salengers Gift Shop | 3547 |
| Square Deal Fruits & Veg. | 3545 |
| Eppes Essen - Delicatessen | 3543 |
| Dry Goods | 3541 |
| Ye Olde Chocolate Shop | 3537 |
| Central Park Theatre (1800 Seats) | 3535 |
| | 3533 |
| Clarence M. Missner Haberdashery | 3531 |
| Economical Drug Co. | 3529 |
| | 3527 |
| A. M. Slabodkin - Furs | 3525 |
| Hidech Bros. Clothing Co. | 3523 |
| Carmen Corset Shop No. 3 | 3521 |
| Arcadia Luggage Shop | 3519 |
| | 3517 |
| | 3515 |
| Nathans Candy | 3513 |
| M. B. Groceries | 3511 |
| John D. Hovorka Gas & Electric Fixtures | 3509 |
| Meat Mkt. | 3507 |
| Bublic Bakery | 3505 |
| | 3503 |

| | |
|---|---|
| 3558 | Delicatessen & Lunch |
| 3556 | Weinstein Bros. Undertakers |
| 3552 | Bowling Alleys |
| 3550 | |
| 3548 | |
| 3546 | Blooms Restaurant |
| 3544 | Realart Printing Co. |
| 3542½ | Meat Mkt. |
| 3542 | J. W. Tauman - Knit Goods |
| 3540 | Berlands Paints & Wall Paper |
| 3538 | Theatre Entrance |
| 3536 | 20th Century Barber Shop |
| 3534 | Becker Cleaner & Dyer |
| 3532 | |
| 3530 | |
| 3526 | Roosevelt Shoe Repair & Hat Cleaners |
| 3524 | Commercial Light Works |
| 3522 | Barber Shop |
| 3520 | Weitzman & Keizerman Restaurant |
| 3518 | H. M. Krivit Haberdashery |
| 3514 | Douglas Russian & Turkish Baths |
| 3512 | |
| 3510 | Hartman Furniture Co. |
| 3506 | Dolly - Frocks |
| 3504 | Barcelona Haberdashery |

Shown are the stores and theaters on the very busy block on Roosevelt Road between Central Park Avenue (3600 West) and St. Louis Avenue (3500 West) in 1929. Among the more popular places on the block were Ye Olde Chocolate Shop, the Balaban and Katz Central Park Theater with 1,000 seats, and the 20th Century Theater across the street with 798 seats. At 3514 West Roosevelt Road was the Douglas Russian and Turkish Baths. (Courtesy of Sherwin Schwartz.)

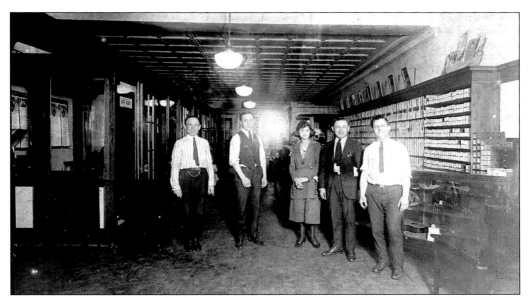

The interior of the National Music store located at 3405 West Roosevelt Road features the booths on the left where one could sample records. The store was founded by Louis Belly (left) in 1915 and closed in 1966 when it was National Television and Radio. The store was the largest distributor (outside of New York) of Hasidic and Jewish records. Yossele Rosenblatt, Richard Tucker, Jan Pearce, Molly Picon, and other notable singers appeared at the store to promote their records. (Courtesy of Pearl Hirshfield.)

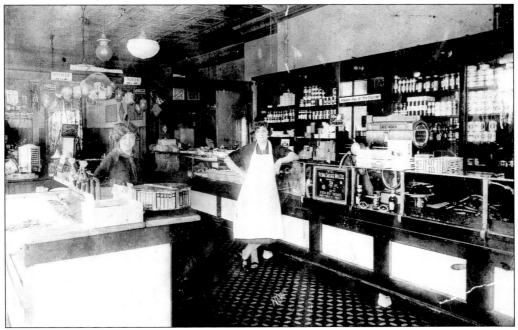

The Rubenstein and Glickman delicatessen was located at Roosevelt Road and Independence Boulevard. On the left is a soda fountain, which was prevalent in many stores of that type. (Courtesy of the Chicago Jewish Archives.)

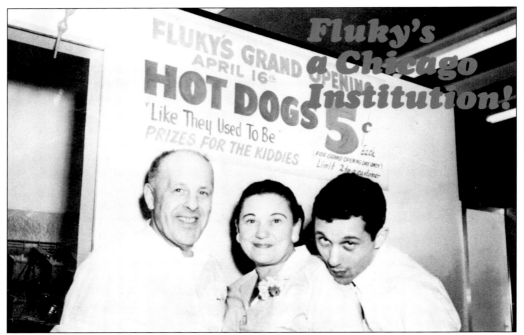

Fluky's, on Roosevelt Road near Central Park Avenue, was probably the busiest place to eat on Roosevelt Road. For a nickel, one could get a tasty hot dog sandwich with all the trimmings and french fries. The server would line up numerous buns on his or her arm and go down the line putting in all the fillers. Fluky's later expanded into different parts of the Chicago area. On the same block were the Central Park and 20th Century Theaters, Ye Olde Chocolate Shop, Best Kosher Sausage, and Silversteins Delicatessen.

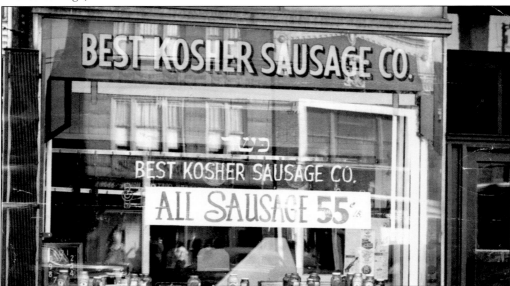

A Best Kosher Sausage store was located near the Central Park Theater at 3521 West Roosevelt Road. The company was later bought by Sara Lee, and Best now no longer exists. Across the street was Lazar's kosher sausage store.

One of the most popular of the numerous restaurants clustered around the intersection of Roosevelt Road and Kedzie Avenue was Carl's Restaurant and Delicatessen. It was especially well known for its huge corned beef sandwiches. Jews would also hang out at Carl's to discuss the problems of the day.

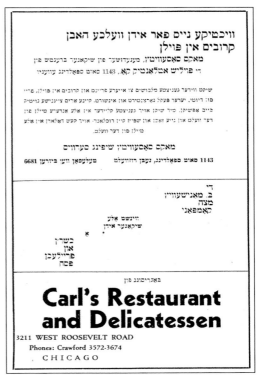

וויכטיקע נייס פאר אידן וועלכע האבן
קרובים אין פוילן

מאַקס סאָסעװויטז, מענעדושער פֿון שיקאַגער בראָנטש פֿון
די פֿױליש אַטלאַנטיק קאָ., 1143 סאָוט ספּאָלדינג עוועניו

שיקט װידער גענוצטע מלבושים צו אייערע פֿריינד און קרובים אין פוילן, פֿריי
פֿון דוטי. יעדער פּעקל גאַ-ראַנטירט און אינשורדו. קינע אַרום ציגישע גוטיש
בײַכ אַפֿשיק. מיר שיקן אױד גענוצטע קליידער אין אַלע אנדערע טײלן פֿון
דער װעלט און נײע זאכן און שפֿיט קיין רופֿלאַנד. אויך קעש דאָלאַרן אין אַלע
טײלן פֿון דער װעלם.

מאַקס סאָסעװויטז שיפֿינג סערװיס

1143 סאָוט ספּאָלדינג, נעבן רחזוועלט          טעלעפֿאָן װיע ביזרעץ 6681

די
ב. מאַניישעװיין
מצה
קאָמפֿאני

הינשם אַלע
שיקאַגער אידן

כשרן
און
פֿרײילעכן
פֿסח

מאַגרוטונג פֿון

# Carl's Restaurant and Delicatessen

3211 WEST ROOSEVELT ROAD
Phones: Crawford 3572-3674
. CHICAGO

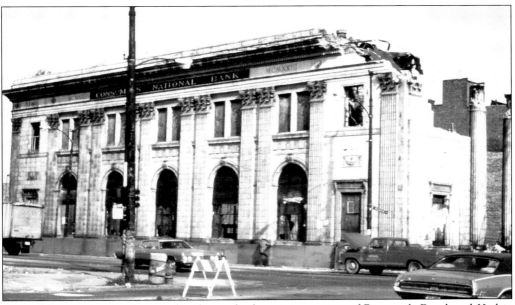

One of the two banks that used to be at the busy intersection of Roosevelt Road and Kedzie Avenue was torn down in 1977. At one time, around that corner were a half-dozen Jewish-owned restaurants. Three streetcar lines, Roosevelt, Kedzie and Fourteenth to Sixteenth Streets, served that junction. The area was decimated during the riots following the assassination of Dr. Martin Luther King Jr. in 1968.

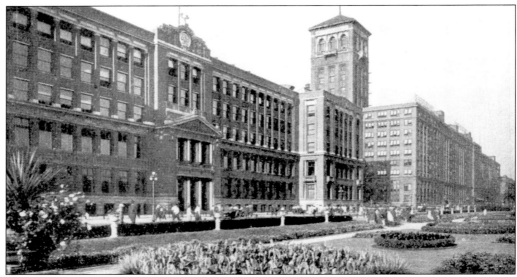

This is part of the huge complex of the Sears, Roebuck and Company world headquarters that was built along Arthington Street in 1906. The site contained the company's administrative, buying, catalog, and merchandizing facilities. It also contained Sears's first retail store. The company employed about 10,000 workers there, including many from the neighborhood. The company headquarters moved downtown in 1974 into the Sears Tower. Its longtime top executive, Julius Rosenwald, was one of the nation's leading philanthropists and a strong supporter of Jewish interests.

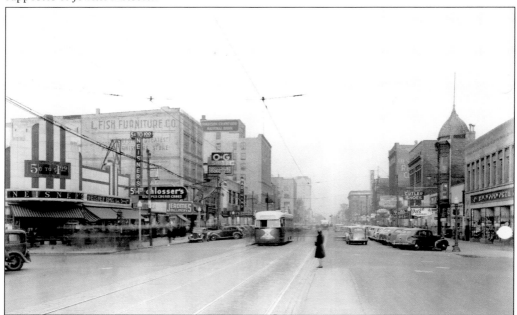

This view is looking east from about Karlov Avenue along Madison Street in 1939 and shows some of the well-known stores of that period such as the Woolworth and Neisner dime stores, OG and Cutler shoe stores, Madigan Department Store, and L. Fish Furniture Company. (Courtesy of the Chicago History Museum, photograph by A. C. Taylor.)

# *Five*

# RECREATION AND ENTERTAINMENT

Recreation in the greater Lawndale area came in many forms. The youngsters kept busy outdoors spinning tops, playing marbles, peg and stick, kick the can, buck-buck how many fingers up, and hide-and-seek, or playing baseball or football in the street or the nearby schoolyard. The girls often played jacks or hopscotch or jumped rope. Occasionally in the evening a fire was started on the street and potatoes were roasted. Renting bicycles from Minky's was common as few owned their own. Indoors one read, played cards or with toys, or listened to favorite radio programs.

Older boys and young men had their low-stake card and dice games hidden from the roving policemen or their Sunday morning baseball games in the nearby schoolyards or parks. The parks were also the place where one could go to see uniformed baseball or football games and use varied recreation facilities.

Some young men would sometimes rent a small, often run-down basement apartment and make a clubhouse out of it, cleaning it up, outfitting it with old furniture, and spending some of their leisure time in their "social and athletic club." On weekends, they often invited girls for dancing and a snack party. Girls would often have parties in their homes, and there would be dancing to radio or phonograph music.

On summer Sundays, various organizations often hired a truck, outfitted it with orange crates for seats, and drove to the forest preserves or the Indiana Dunes for a picnic. Or sometimes people would go to Riverview Park or Navy Pier.

Jews of all ages used the libraries or participated in the local cultural and recreational activities of the JPI. Many went regularly to the neighborhood movie theaters. There were six movie theaters along Roosevelt Road plus numerous restaurants and banquet halls. Those from the old country usually went to the neighborhood Yiddish theaters.

In the summer, those families who could afford it would go "to the country," especially to the Indiana Dunes or to Union Pier and South Haven in Michigan. There they would rent cottages or stay at boardinghouses or resort hotels, most of them kosher and some with good entertainment. South Haven, the largest of these areas, had 55 Jewish resort facilities, and the area became known as the "Catskills of the Midwest."

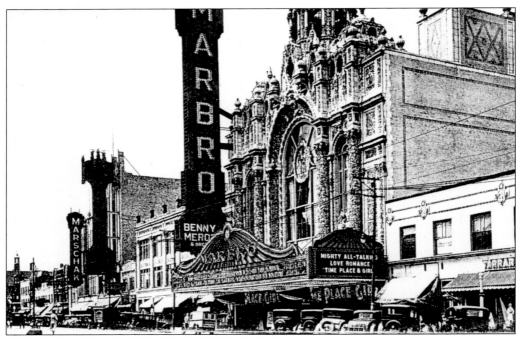

The Balaban and Katz large first-rate Marbro Theater was located on Madison Street just west of Crawford Avenue (now Pulaski Road), seen around 1930. The theater featured a stage show as well as a movie. It was an integral part of the busy Madison-Crawford shopping area.

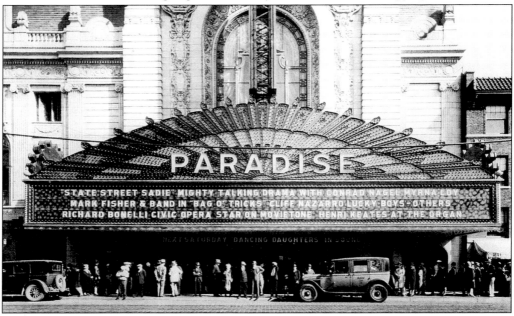

The Balaban and Katz Paradise Theater was located at 231 North Crawford Avenue, seen in 1928. For a while, the theater had a nursery where patrons could leave their children. It also had a lavish interior, sculptures, and stars in the ceiling. The theater, now gone, inspired an album by the Chicago-bred rock band Styx.

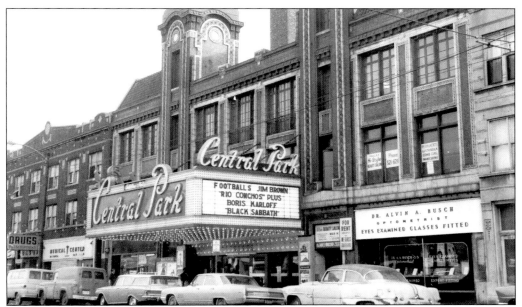

The Central Park Theater, located at 3535 West Roosevelt Road, was the first of the numerous movie palaces built by the duo of Barney Balaban and Sam Katz. The building was designed by Cornelius and George Rapp, the men who also designed the Chicago Theater and other Balaban and Katz movie palaces. The building is now an African American church. (Courtesy of the Theatre Historical Society of America.)

The interior of the Central Park Theater featured beautiful chandeliers, hundreds of velour-covered seats, hand-painted murals, and interesting sculpturing. As an added feature, it was one of the first to have ice-cooled air to bring relief on hot and humid summer days. It also originally featured live entertainment, including a local musician named Benny Goodman. (Courtesy of the Theatre Historical Society of America.)

Alex. L. Levy                    Architect.

## GOLD THEATRE
### CHICAGO

The Gold Theater was located on Roosevelt Road near Homan Avenue. It was one of the six movie theaters that were along Roosevelt Road in the mile between Kedzie Avenue and Crawford Avenue. (Courtesy of the Theatre Historical Society of America.)

The Rena Theater was located on Roosevelt Road near Crawford Avenue. For a while it served as a Yiddish theater featuring a variety of Yiddish plays. At that time, it was known as the Lawndale Theater. (Courtesy of the Theatre Historical Society of America.)

The Lindy Theater was located at 3436 Ogden Avenue near Trumbull Avenue. The movie theater was located almost on the boundary between the Jewish community of North Lawndale to the north and the Bohemian community of South Lawndale to the south.

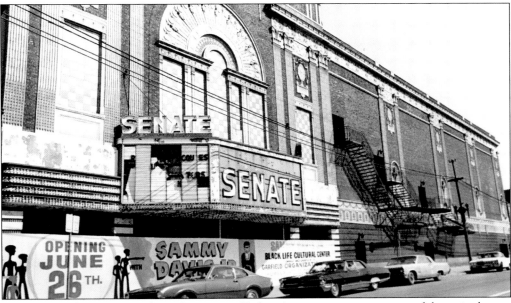

The Senate Theater on Madison Street near Kedzie Avenue was once a successful movie theater near a busy intersection. It was across the street from the popular Little Jack's Restaurant, especially known for its cheesecake. This March 1973 photograph shows its ruined state after the riots of 1968, which damaged large sections of Madison Street. (Courtesy of the Chicago History Museum, photograph by Joseph G. Domin.)

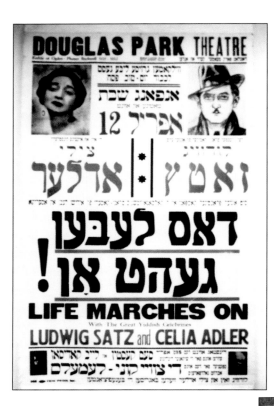

This Douglas Park Theatre billboard was posted throughout greater Lawndale. The theater, operating from 1938 to 1951, was the last Yiddish theater in Chicago and was located in North Lawndale at Kedzie and Ogden Avenues. One of the young actors there was Bernie Schwartz (Tony Curtis). Other prominent actors and actresses included Aaron Lebedeff, Michael Michalesko, Molly Picon, Maurice Schwartz, Menasha Skulnik, Pesache Burstin, Dina Halpern, and Leo Fuchs.

Menasha Skulnik was a very popular Yiddish comedian who performed frequently at the Douglas Park Theatre, which was located in the Douglas Park Auditorium. The theater was supported by over 100 Jewish organizations that purchased blocks of tickets on a benefit basis.

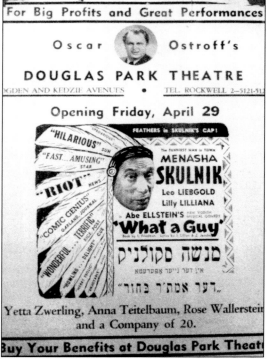

Molly Picon was a popular Yiddish actress who performed in Chicago on numerous occasions. She appeared in both the Yiddish and English movie versions of *Fiddler on the Roof*. She performed in many foreign countries and also on the English stage.

Molly Picon

Dina Halpern (1910–1989), a renowned Yiddish actress in pre–World War II Poland, later settled in Chicago where she appeared in many Yiddish plays in Lawndale. She was married to Danny Newman, a prominent theatrical publicist and executive.

The JPI had children and adult theater groups. It was the sponsor of the Institute Players. This c. 1940 play was performed in the institute's large auditorium.

Shelley Berman (1926–) is one of the prominent social critic comics of the time. He lived in Lawndale and attended George Howland Elementary School there. He has made numerous stage, radio, and television appearances.

A young Benny Goodman (1909–1986), later known as the "King of Swing," performs with the Women's Symphony Orchestra in Grant Park in August 1941. Born in the Maxwell Street area, he later moved to 1125 South Francisco Avenue in North Lawndale and attended a synagogue Hebrew school there. His was one of the first jazz ensembles where both black and white musicians played together. As a clarinetist, he made numerous appearances with symphony orchestras, and he performed before royalty as well as in Carnegie Hall.

This advertisement for a pioneer radio Jewish fund-raiser program in 1928 features such Jewish stars as Eddie Cantor, Fannie Brice, and Paul Ash and his popular orchestra.

**The United Drive News**
$4,000,000

VOL. II    NO. 4

## TUNE IN!              TUNE IN!
# Saturday   Night
**Tonight At Seven O'Clock Sharp**
**Station W-L-I-B**
(Wave length 302.8 Meters)

# Eddie Cantor
Actor and Vice-Chairman is Broadcasting his first Chicago program.
### He Is A Jew.
He came up to Headquarters as a volunteer worker.
He was made a Vice-Chairman.
He arranged for this program.
He himself is going to play a big part in it.
He has persuaded

# Fannie Brice
# Paul Ash and his famous orchestra
### and other wonderful Jewish artists to participate.

If you want to know why he is doing all this for us,
for you and for our people,

## TUNE IN!              TUNE IN!
At Seven O'Clock SHARP

PINSKER

CHASIDIM

BALL

Given by

Pinsker Branch 252 W. C.

»» and ««

Pinsker Independent Society

Saturday, January 30th, 1932
at WORKMEN'S CIRCLE LYCEUM
Kedzie and Ogden Avenues

Chasidim Featured by Pinsker Kapelie
Assisted by Meyer Rosen

This ball in Lawndale was sponsored by the Pinsker Chasidim branch of the Workmen's Circle. The branch consisted largely of Jewish immigrants from the large community of Pinsk, which had a large Jewish population, many of them Hasidic, a mystical and pietistic religious movement that originated in 18th-century Poland. The Workmen's Circle was a fraternal, labor-oriented, largely Jewish immigrant group that had welfare programs and ran camps and schools using the Yiddish language.

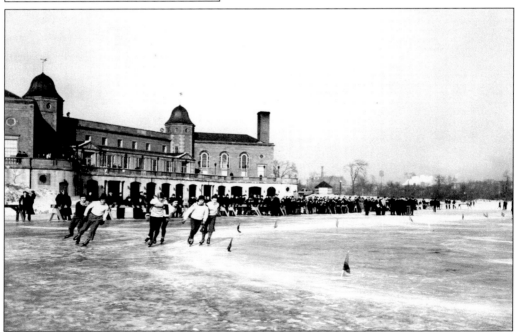

This photograph features ice skate races on the Douglas Park lagoon around 1936. In the background is the Douglas Park field house, which housed rowboats that could be rented in the summer. (Courtesy of the Chicago Park District.)

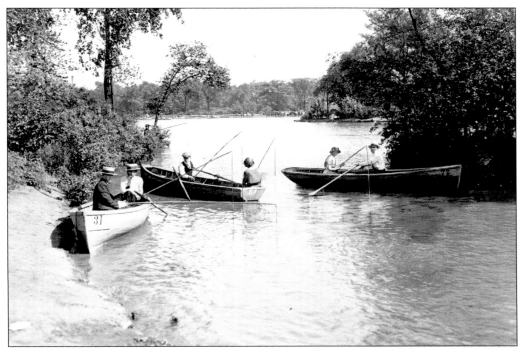

Visitors are seen here fishing in the Garfield Park lagoon in 1921. The lagoon was first stocked with fish, many edible, in the late 1880s. (Courtesy of the Chicago Park District.)

This advertisement in the *Sentinel* publicizes two of the major Jewish summer resort areas, Union Pier and South Haven, both in the state of Michigan. (Courtesy of the Sentinel Publishing Company.)

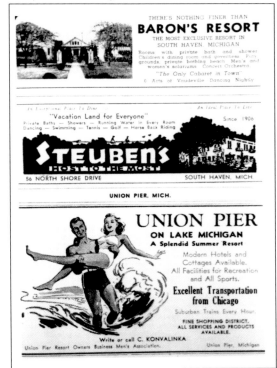

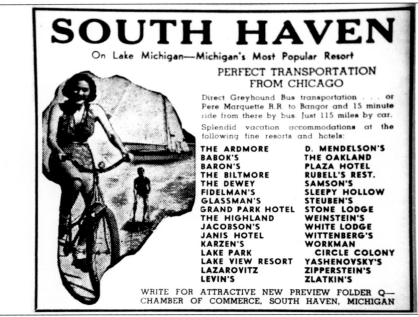

# SOUTH HAVEN

## On Lake Michigan—Michigan's Most Popular Resort

### PERFECT TRANSPORTATION FROM CHICAGO

Direct Greyhound Bus transportation . . . or Pere Marquette R.R. to Bangor and 15 minute ride from there by bus. Just 115 miles by car.

Splendid vacation accommodations at the following fine resorts and hotels:

| | |
|---|---|
| THE ARDMORE | D. MENDELSON'S |
| BABOK'S | THE OAKLAND |
| BARON'S | PLAZA HOTEL |
| THE BILTMORE | RUBELL'S REST. |
| THE DEWEY | SAMSON'S |
| FIDELMAN'S | SLEEPY HOLLOW |
| GLASSMAN'S | STEUBEN'S |
| GRAND PARK HOTEL | STONE LODGE |
| THE HIGHLAND | WEINSTEIN'S |
| JACOBSON'S | WHITE LODGE |
| JANIS HOTEL | WITTENBERG'S |
| KARZEN'S | WORKMAN |
| LAKE PARK | CIRCLE COLONY |
| LAKE VIEW RESORT | YASHENOVSKY'S |
| LAZAROVITZ | ZIPPERSTEIN'S |
| LEVIN'S | ZLATKIN'S |

WRITE FOR ATTRACTIVE NEW PREVIEW FOLDER Q—CHAMBER OF COMMERCE, SOUTH HAVEN, MICHIGAN

South Haven, Michigan, was the major Midwest Jewish summer resort with an estimated 55 Jewish-owned vacation facilities. Some 75,000 people from all over the Midwest would jam into South Haven on a nice summer weekend, and it became known as a miniature Catskill borscht belt—without the mountains.

Young Jewish women eat hot dogs in South Haven, Michigan, during the flapper era of the 1920s. South Haven was a popular summer resort for Chicago's West Side Jews.

# *Six*

# EVENTS

There were numerous major events that affected the lives of the West Side Jews. Some were extremely tragic, like the Holocaust, and others were hopeful, like the founding of the State of Israel.

Even before the Holocaust, the Jewish community experienced anxiety about the plight of the Jews in eastern Europe, where there were not only restrictions and anti-Semitism but also pogroms such as the virulent 1903 Kishinev Massacre in Russia and the turmoil created by World War I. To help their European brethren, there were protests and special organizations set up to aid the eastern European Jews and efforts by the various *landsmanshaften* to send help in the form of money and packages and to pressure Congress not to curtail the flow of Jewish immigrants. The Hebrew Immigrant Aid Society (HIAS) tried to aid the Jewish immigrants as much as possible. The joint distribution committee sent Bernard Horwich and Judge Harry Fisher to eastern Europe to help organize and report on the relief effort.

During the period between the two world wars, when new organizations were formed, the Zionist movement also grew strongly, as the need for a haven for the Jews became more imperative. Despite some restrictions on Jews as to employment, education, and residence, the Jewish community generally prospered during this period, although the Great Depression slowed the progress. The first Jewish governor of Illinois, Henry Horner, was elected in 1932. In 1933, the Jewish community staged the very successful Jewish Day at the Century of Progress, attended by 125,000 people.

When Adolf Hitler came into power in 1933, the Chicago Jewish community began to take steps to help the beleaguered German Jews and later the other European Jews who faced the catastrophic Holocaust and its aftermath. Virtually every Jewish organization embarked on programs of help. Additionally, thousands of West Side Jews served in the armed services, worked in defense plants, or volunteered in war effort causes.

Two days after the creation of Israel, a huge celebration, the Salute to the New Jewish Republic, was held in the Chicago Stadium with over 50,000 attending. More significant than the celebration was the effort of the Jews of Chicago to help Israel in its struggle against the invasion of the armies of five Arab countries by funneling personnel, money, and arms into Israel. About the same time Jews were returning to Israel, Jews started leaving greater Lawndale.

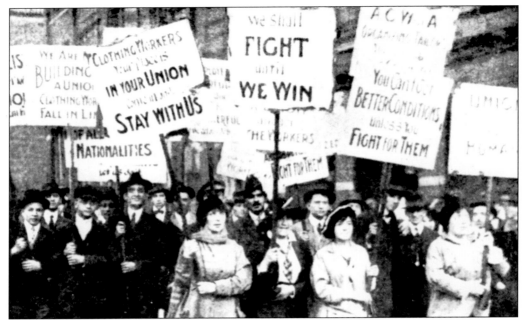

Some of the 40,000 garment workers, about 80 percent Jewish, who went on strike in 1910 are pictured here. The bitter 17-week strike resulted in some concessions for the workers and the strengthening of their union organization. Major strike leaders were Sidney Hillman (1887–1946) and Bessie Abramowitz Hillman (1889–1970).

A special Yiddish edition of the *Chicago American* was released on October 20, 1913. The headline reads, "Chicago protests against Czar." Some 25,000 people had rallied downtown denouncing the Russian government's trial of a Jewish worker, Mendel Beilis, accused of killing a Russian boy to obtain human blood alleged to be necessary for Passover services. Among those speaking at the rally were Jane Addams, Booker T. Washington, and Rabbi Emil Hirsch. After a worldwide protest, Beilis was acquitted. (Courtesy of *History of the Jews of Chicago*.)

U.S. marine Samuel Meisenberg, an 18-year-old European-born Jewish immigrant, was the first American killed in the landings at Vera Cruz, Mexico, in 1914. His funeral on May 14, 1914, attracted thousands in front of the Anshe Kanesses Israel Synagogue. Among the many tributes was one from Secretary of the Navy Josephies Daniels. (Courtesy of the Chicago History Museum.)

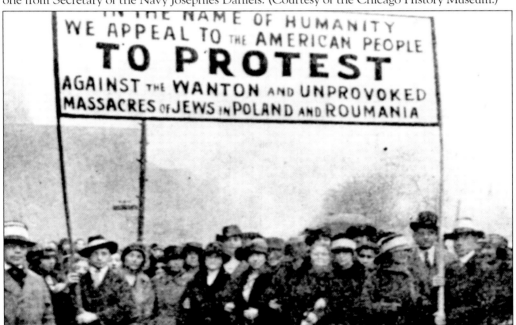

A march was held on May 30, 1919, of 25,000 Jews on the West Side carrying signs protesting the treatment of Jews in Poland and Romania. The marchers are heading to a mass meeting at the auditorium and then would continue to downtown. (Courtesy of the Sentinel Publishing Company.)

# THE ALL-RUSSIAN JEWISH PUBLIC COMMITTEE
### For the Relief of War and Pogrom Sufferers
#### 110 WEST 40th STREET, NEW YORK CITY

## N° 6177

| Purchaser's Receipt | Food Draft Receipt |
|---|---|

Date.......... Sept.1/22 ........ 5992
......192..

Received from M. Henry Rothman ............... the sum of.. ten dollars ($ 10.-..)

(Address—Street) 1236 So. Turner Ave.,

(Town and State) Chicago, Ill.

Representing the value of food deliverable for above amount, in accordance with arrangement detailed on back thereof, and which is hereby made a part of this receipt.

Foodstuffs to be delivered to:

Моисей Стражник

Андреевская ул., №9, кв.7

г. Киев.

THE ALL-RUSSIAN JEWISH PUBLIC COMMITTEE
Bureau of the Representative in U.S.A. and Canada
per

THE ALL-RUSSIAN JEWISH PUBLIC COMMITTEE will deliver to the designated beneficiary in Russia, for each $10., paid to its American Bureau, the following foodstuffs:

| | | |
|---|---|---|
| 50 | lbs. of | White Flour |
| 20 | " " | Rice |
| 10 | " " | Grits |
| 10 | " " | Sugar |
| 10 | " " | Fat (Beef or Crisco) |
| 3 | " " | Kosher Corn Beef (or 5 cans of Salmon) |
| 3 | " " | Cocoa |
| 5 | " " | Soap |
| 10 | tins of | Condensed Sweet Milk |

120 lbs.

In addition, for each 120 lbs. of foodstuffs delivered to the designated beneficiary in Russia, the ALL-RUSSIAN JEWISH PUBLIC COMMITTEE will assign 40 lbs. of foodstuffs for general relief.

If at the end of 90 days after receipt of advise the local Committee in Russia is unable to locate the beneficiary, it will notify the American Bureau, and the original $10.00 will be refunded to the donor.

The delivery of foodstuffs in Ukraine and White Russia will be made through the branches of the ALL-RUSSIAN JEWISH PUBLIC COMMITTEE. In places where there are no branches of the Committee, delivery will be made through the post office or any other available service, but only upon the written consent of the beneficiary.

Pictured is a receipt for a food package sent in 1922 by a Lawndale resident to his relatives in Russia. There were agencies that specialized in sending food packages mainly from immigrants to their families and friends left behind in the old country.

Here is a campaign poster in Yiddish to elect Henry Horner as governor in 1932. He was reelected in 1936 despite opposition from the Democratic machine of Chicago. The namesake son of one of the earliest German Jewish settlers of Chicago, he had previously served 18 years as a distinguished judge of the probate court of Cook County. Horner was very active in Jewish and general civic community affairs. (Courtesy of the Jewish Federation of Metropolitan Chicago.)

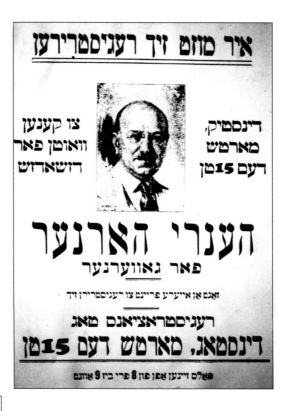

**DEBATE**

UNDER AUSPICES OF

**TEMPLE JUDEA MEN'S CLUB**

**CLARENCE DARROW**
Rabbi **SOLOMON GOLDMAN**

"**IS RELIGION NECESSARY**
AT
**ORCHESTRA HALL**
**MONDAY EVENING, MAY 18, 1931**
AT 8:15

MAIL ORDERS NOW TO ORCHESTRA HALL
**TICKETS ON SALE AT BOX OFFICE AFTER MAY 8TH**

Or Tickets may now be secured at Home of
H. B. Ritman President Temple Judea Men's Club
33 N. La Salle Street Room 2221 Phone Randolph 6390

Temple Judea, located at 1227 Independence Boulevard, was the only Reform Jewish congregation in the immediate Lawndale area. Because of customs such as men and women sitting together, it was looked upon with some suspicion by the much larger Lawndale Jewish Orthodox community. This debate, staged by its men's club in 1931, features two of Chicago's most famous men.

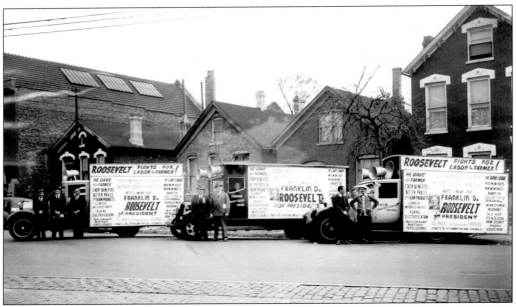

Here residents campaign for the reelection of Pres. Franklin Delano Roosevelt in 1936. The 24th Ward, which covered most of North Lawndale, gave 95.95 percent of its votes to Roosevelt. Jacob Arvey, the Democratic political boss and alderman of the 24th Ward, once said the only ones voting Republican in his ward were the Republican precinct captains, their election judges, and their families. (Courtesy of the Amalgamated Clothing Workers of America.)

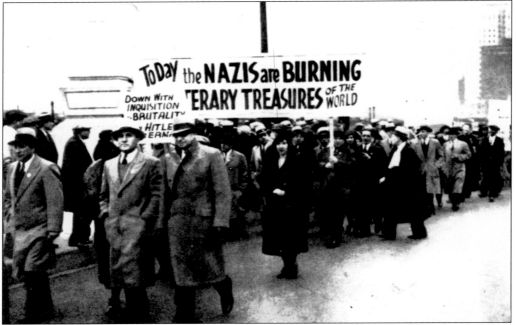

A portion of an anti-Nazi protest demonstration by Jews and others downtown is pictured on May 10, 1933, the day the Nazis were burning books written by Jews, democrats, and liberal and social revolutionaries.

The cover of the *Sentinel*, a weekly started in 1911, commemorates Jewish Day on July 3, 1933, at the Century of Progress world's fair. A cast of 6,000 Jewish singers, dancers, and actors took part in the production called *The Romance of a People*. A capacity crowd of 125,000 people attended the event at Soldier Field.

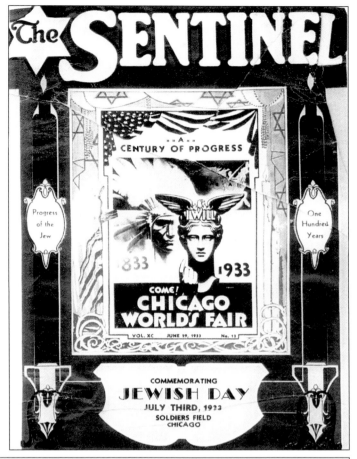

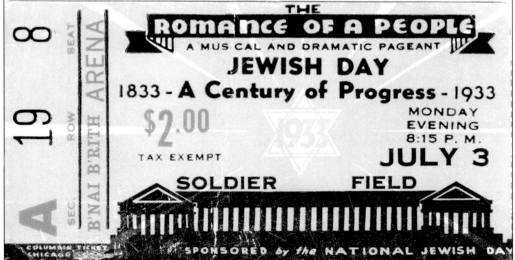

A ticket to attend the Jewish Day *The Romance of a People* program at the Century of Progress world's fair on July 3, 1933, at Soldier Field is seen here.

Pictured is part of the crowd at Soldier Field on July 3, 1933, at the Century of Progress world's fair watching the pageant *The Romance of a People*, which depicted highlights of Jewish history. The guest speaker was Chaim Weizmann, who in 1948 became the first president of Israel. (Courtesy of the Chicago Jewish News.)

During the Depression of the 1930s, many Jews from the Lawndale area found work at the 1933–1934 Century of Progress in Chicago, a world's fair along the lake from Roosevelt Road south to Thirty-seventh Street. Depicted is the employee identification card of a Lawndale resident. (Courtesy of Sheldon Robinson.)

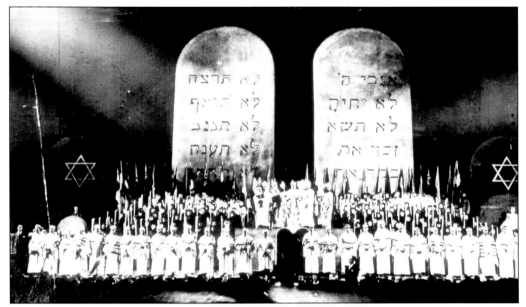

The pageant *We Shall Never Die*, written by Ben Hecht, was performed to a capacity crowd in the Chicago Stadium on May 19, 1943, in the middle of World War II. Its purpose was to expose the horrors of Nazi Germany and to raise money for Palestine. Music was by Kurt Weil, and narrators were John Garfield, Burgess Meredith, and Jacob Ben-Ami. (Courtesy of Janice Schurgin.)

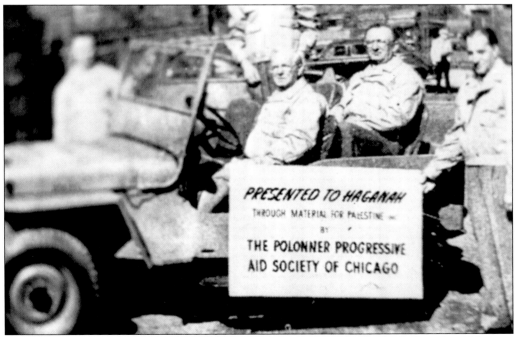

A jeep donated by a Jewish fraternal agency during the 1940s to Haganah, the Jewish self-defense force in Palestine, is shown here. (Courtesy of the Jewish Federation of Metropolitan Chicago.)

A collage of articles from the *Marshall News* in 1945 depicts the war efforts of the students. John Marshall High School students participated in such activities as scrap drives, war bond drives, blood donations, Red Cross participation, and providing gifts and entertainment for those in the military. (Courtesy of Sherwin Schwartz.)

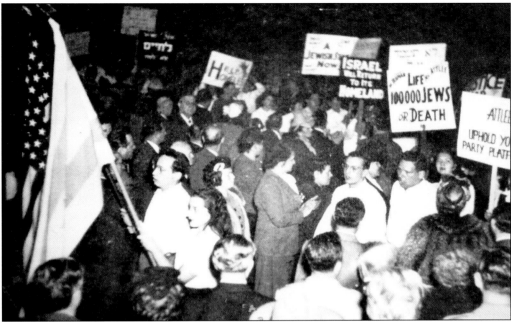

Jewish protestors rally around 1947 in support of a homeland for the Jews in Palestine and against the British policy of Prime Minister Clement Attlee of keeping Jewish refugees out of Palestine. (Courtesy of the Sentinel Publishing Company.)

A call was made to celebrate the fulfillment on May 14, 1948, of a 2,000-year-old dream by the establishment of the State of Israel. Massive rallies were backed by most Jewish groups. (Courtesy of Jerome Robinson.)

## BE THANKFUL!
### for the fulfillment of a 2000 years' dream
SALUTE JEWISH STATE IN PALESTINE!

## Show your appreciation--
### Observe this Holiday by closing all **Stores, Factories, Shops** and **Offices,** all day **Saturday, May 15**

Gather in masses, SABBATH, MAY 15th, at your holy places of worship and offer a prayer of thanks for the Jewish State.

DO NOT FAIL TO PARTICIPATE IN THE RALLY AT THE CHICAGO STADIUM

## Sunday, May 16th, 8 P. M.

Merkaz Harabanim of Chicago
Chicago Rabbinical Council
Rabbinical Council of Chicago
Rabbinical Assembly of America
Rabbinical Association of Chicago
Union of Orthodox Jewish Congregations of America
United Synagogues of America
Chicago Bnai Brith Council
Council of Conservative Synagogues
Hashamer Hadati of Chicago
Hapoel Hamizrachi of America
Mizrachi Organization of America
Young Israel of America

Associated Talmud Torahs of Chicago
Rabbi Eliezer Silber, Chief Rabbi of Cincinnati, Ohio
Hebrew Parochial School of Chicago
* Board of Jewish Education
* Jewish War Veterans of America
Synagogue Division, Jewish Welfare Fund
Vaad Hatzalah of America
Vaad L'Maan Hashabbos
American Jewish Congress
Zionist Organization of America
* American Federation for Polish Jews

An elderly Jew attends a rally in the Chicago Stadium on May 16, 1948, celebrating the establishment of the State of Israel. (Courtesy of the Chicago Tribune.)

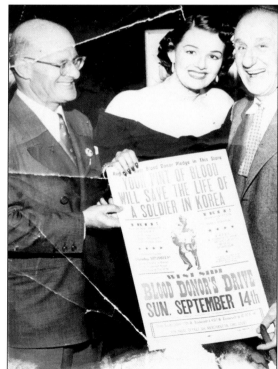

A blood drive during the Korean War shows Ald. Jacob Arvey (left) of the 24th Ward, an unknown model, and the comedian Jimmy Durante, who helped publicize the drive around 1951.

# *Seven*

# EXODUS

Shortly after World War II, the Jewish West Side started undergoing rapid change. It changed from Jewish to African American between the late 1940s and early 1950s, although some Jews had started leaving earlier. However, the Jewish West Side had hardly deteriorated physically and was still an attractive area.

There were many factors that caused the rapid mass exodus from the Jewish West Side. The Jews generally had moved up economically and became interested in areas with more amenities and in areas that had been previously restricted to them. Increased mobility offered by the automobile and expressways and favorable housing loans offered by the government made owning their own homes easier. There were few single-family homes in North Lawndale. Some residents moved south into the South Shore, but most moved into North Side communities and suburbs like Skokie and Lincolnwood and then continued farther north and northwest.

As the Jews moved out, the burgeoning African American population from the crowded vicinity to the east began to move with virtually no hostility into the Jewish West Side, soon making the area almost all African American. At first the neighborhood held up quite well, but then as poorer African Americans crowded in, the neighborhood began to show signs of deterioration. The riots in 1968 were disastrous to the area. Whole blocks of Madison Street, Roosevelt Road, and other sections were burned out. The economic base of the community declined drastically, and many stores and industries closed and insurance rates skyrocketed. The foreclosure, abandonment, or arson to homes left the area with thousands of vacant lots and a high crime and drug rate.

In recent years, however, there have been some improvements as a few chain stores have started coming back and scattered new housing developments, like Homan Square, have been built. With government and private investment, new facilities such as a bank, a YMCA, several schools, a community center, and several large apartment buildings have been erected. Although the population is now well less than half of what it was in 1950, there are a number of government and private agencies working hard to improve the area and have brought regeneration to parts of the neighborhood. Most of the institutions built by the Jewish community, especially the synagogues, still stand and are well used by the current residents as the ever-changing pattern of ethnic succession continues in Chicago neighborhoods.

An African American couple is welcomed into North Lawndale by their Jewish neighbors in the late 1940s. The transition in the neighborhood was a peaceful one with virtually all the Jews gone by the late 1950s. (Courtesy of the Sentinel Publishing Company.)

Musician Benny Goodman crowns the first African American queen of North Lawndale in 1953—an indication of the rapid population change that had taken place in the community.

The official archway entrance to the "Little Village" of South Lawndale on Twenty-sixth Street near Kedzie Avenue is seen here in 2006. The archway and clock were dedicated by the president of Mexico. Formerly a major Bohemian shopping street, now for about two miles the street is a very busy Mexican shopping area.

Part of the Harrison Courts apartment complex, located around Harrison Street and California Avenue, is seen here. It is one of the oldest surviving public housing projects in the city. The public housing complex on Ogden Avenue near Talman Avenue has been torn down.

111

The former Anshe Sholom Congregation located at Independence Boulevard and Polk Street is now the African American Independence Boulevard Seventh-Day Adventist Church. The church has kept almost all the symbolism of the synagogue, including the cornerstone and the windows with Jewish religious symbols. (Courtesy of the Independence Boulevard Seventh-Day Adventist Church.)

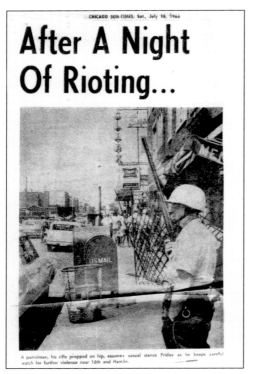

CHICAGO SUN-TIMES, Sat., July 16, 1966

# After A Night Of Rioting...

A patrolman, his rifle propped on hip, assumes casual stance Friday as he keeps careful watch for further violence near 16th and Hamlin.

A patrolman with his rifle keeps a careful watch for further violence near Sixteenth Street and Hamlin Avenue near the William Penn Elementary School on July 15, 1966. Two years later, after the assassination of Dr. Martin Luther King Jr., some of this area was destroyed. (Courtesy of the Chicago Sun-Times and Sherwin Schwartz.)

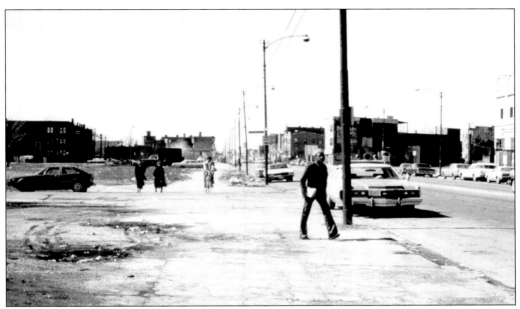

This view is looking west on Roosevelt Road from Kedzie Avenue in 1970. The vacant blocks on the left were burned out during the riots in 1968 following the assassination of Dr. Martin Luther King Jr. These blocks previously housed such popular places as Carl's Restaurant and Delicatessen, the Circle Theater, and B. Nathan Dress Shop, followed for more than a mile by other well-known Jewish stores, theaters, restaurants, and meeting halls. Directly across the street had been Zookie the bookie and Davy Miller's Pool Hall.

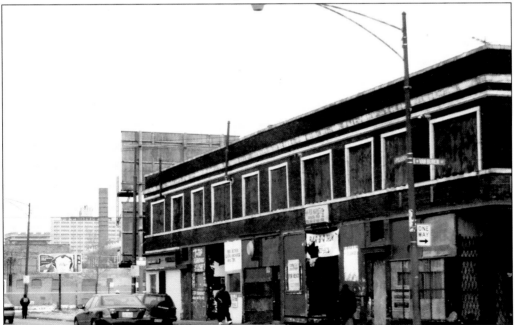

Abandoned stores on Pulaski Road near Van Buren Street, which once housed numerous community-oriented shopping facilities, are seen here in 2008.

The east side of Kedzie Avenue between Roosevelt Road and Thirteenth Street, pictured in 1978, had not recovered from the devastating riots of 1968.

The once fine apartment buildings on Douglas Boulevard are seen here boarded up. Some were badly damaged during rioting. The building in the background was the First Romanian Congregation (Shaari Shomayim), which was located at 3622 Douglas Boulevard. The building is now Stone Temple Missionary Baptist Church, a popular African American church.

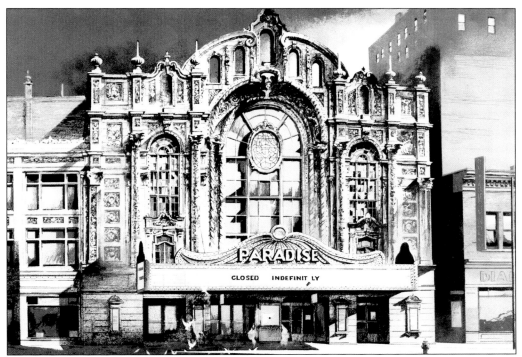

The last days of the Balaban and Katz Paradise Theater, located at 231 North Pulaski Road, are seen here around 1975. The beautiful theater was subsequently torn down as the once bustling commercial area and neighborhood deteriorated. (Courtesy of Debra M. Greenberg.)

Pictured is the former Weinstein funeral chapel building that is still standing on Roosevelt Road near Lawndale Avenue in 2009. Part of the building is now used as an African American church.

The site of the relatively new Mount Hebron Missionary Baptist Church at 3455 Douglas Boulevard, seen in 2008, formerly was the site of Congregation Beth Hamedrosh Hagodol UB'nai Jacob Anshe Luknick Synagogue. It was one of the few synagogues on the Jewish West Side that was torn down. Most were converted into African American churches.

Pictured here is a makeshift open-air market on Pulaski Road just south of Jackson Boulevard in the West Garfield Park area in 2008. A number of such markets now exist in the area.

A food stand at the corner of Harrison Street and Independence Boulevard in 2008 is taking advantage of the famous Maxwell Street name of the marketing area on the Near West Side started by the eastern European Jews that flourished for over a century until officially closed by the city in 1994.

The Neighborhood Housing Services of Chicago is located at 3555 West Ogden Avenue and is headed by Charles Leeks in North Lawndale. Its purpose is to improve the neighborhood housing, environment, and pride through spurring reinvestment, fostering home ownership, providing the resources for property improvement, and generally bringing about positive change.

The Beth Jacob Anshe Kroz Synagogue was located at 3540 West Fifteenth Street. It was founded in 1899 in the Maxwell Street area. In North Lawndale, it was directly across the street from Congregation Anshe Lebovitz. The building now houses an African American church, seen in 2009.

When a Starbucks coffee shop opened a few years ago on the corner of Roosevelt Road and Homan Avenue, the Lawndale community was elated, assuming it was a sign the community was coming back. However, in 2008, probably due to insufficient business, Starbucks closed. In the left background is the original Sears Tower that was part of the large Sears, Roebuck and Company spread along Arthington Street.

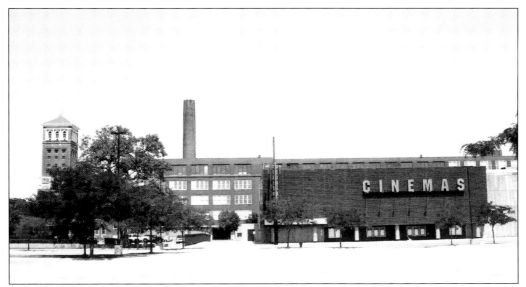

The Lawndale Cinema complex in a shopping strip along Roosevelt Road near Homan Avenue lasted only a few years before it closed down, presumably for the lack of enough business, although it was the only theater in the whole area. In the background is the original Sears Tower.

The Lawndale Plaza shopping mall, which opened in 1999 on Roosevelt Road between Kedzie and Homan Avenues, is seen here in 2005. The Lawndale Cinema in the background and also a Dominick's are now closed, as are some of its other stores.

This apartment building was erected in the 1980s on the site where the popular Graemere Hotel once stood opposite Garfield Park on Homan Avenue.

Seen here in 2009, the North Lawndale College Prep–Collins Academy, a relatively new public high school, is located in the northern part of Douglas Park, just south of Roosevelt Road and east of Sacramento Boulevard. The greater Lawndale area also had a number of new public elementary schools built there.

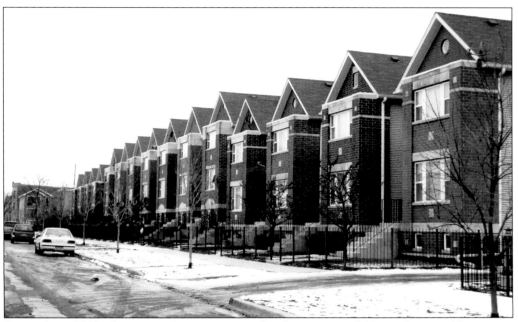

Pictured in 2009, these new homes are on the former site of Victor Lawson Elementary School, which was located at 1256 South Homan Avenue. Of the school's about 2,000-student enrollment in the 1930s, over 90 percent were Jewish. Some of the school's alumni kept meeting for decades.

A sign that the North Lawndale neighborhood is gradually coming back in spots is shown by the substantial price of town houses, $399,900. This complex of homes is on the former site of the Orthodox Jewish Home for the Aged at Ogden and Albany Avenues opposite Douglas Park and is seen in 2009.

Seen here is the private large Homan Square housing development where single-family homes were selling for almost $300,000 in 2009. The large development stretches from Homan Avenue to Central Park Avenue along Arthington Street. It is located adjacent to the former Sears, Roebuck and Company complex, and the original Sears Tower is visible in the center background.

The new North Lawndale YMCA, pictured in 2008, is located on Arthington Street near St. Louis Avenue. It is near the new community center. Both places have provided needed facilities and have helped in stabilizing the community.

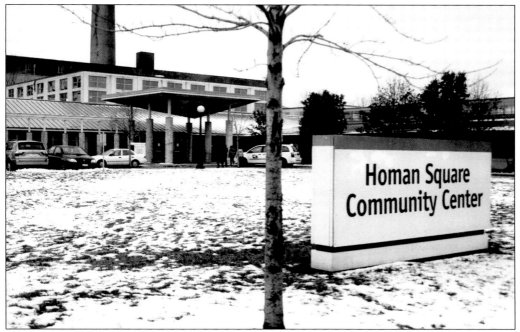

The new Homan Square Community Center at Arthington Street near St. Louis Avenue is seen here in 2008, on the boundary between the North Lawndale and East Garfield Park communities. Its multipurpose activities serve all ages of the local communities.

Pictured are former North Lawndale resident heavyweight boxing champion Ernie Terrell and his sister Jean (center), who replaced Diana Ross in the Supremes. An accomplished singer, Ernie Terrell also had a career as a music producer in Chicago. He ran unsuccessfully for alderman of Chicago's 34th Ward in 1987.

Dinah Washington (1924–1963) was a well-known blues and jazz singer sometimes called the "Queen of the Blues." She had many records on top 10 hit lists, winning a Grammy Award in 1959 for "What a Difference a Day Makes." In 1948, she purchased a two-flat building at 1518 South Trumbull Avenue and was one of the first African Americans to move into North Lawndale. Her mother and children resided there for many years. (Courtesy of the Chicago History Museum.)

The former large Kehilath Jacob Synagogue, now an African American church, has its exterior covered with plastic as it undergoes repairs in 2009. Located on Douglas Boulevard and Hamlin Avenue, it was one of the larger synagogues in North Lawndale. Benny Goodman went to its Hebrew school.

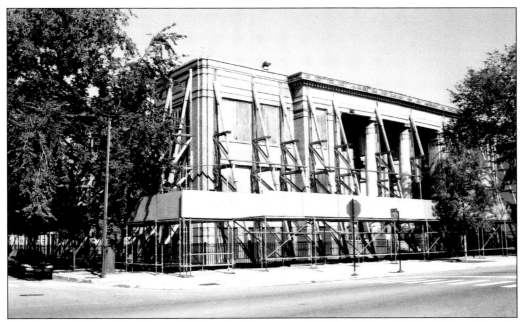

The former Hebrew Theological College building opened in North Lawndale in 1922 at Douglas Boulevard and St. Louis Avenue. It moved to Skokie in 1958. The old building is undergoing reconstruction to make it an intergenerational center with facilities for seniors on the first floor and for teenagers on the second floor.

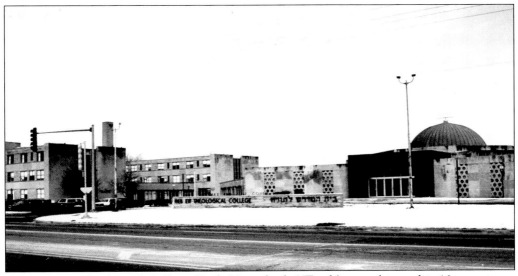

The Hebrew Theological College (Beth Hamedrash L'Torah) moved into this 16-acre site at 7135 North Carpenter Road in Skokie in 1958 after 35 years in North Lawndale. Through the years, the college has ordained over 500 Orthodox rabbis, and thousands of others have attended its ancillary facilities, which include a teachers' institute for women and a high school.

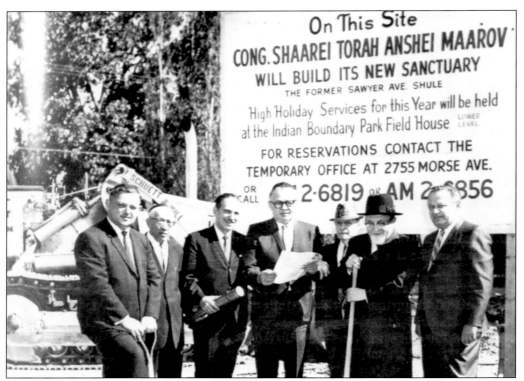

The groundbreaking for the new home of Congregation Shaarei Torah Anshei Maarov at 2756 West Morse Avenue was captured in this photograph taken in 1968. The synagogue, once the oldest in North Lawndale, had been located for many years at Sawyer Avenue and Thirteenth Street. It was one of many North Lawndale synagogues that moved to West Rogers Park. (Courtesy of the Sentinel Publishing Company.)

As one now goes through Chicago's Jewish West Side and views the former JPI, the Hebrew Theological College, the Douglas Park Auditorium, and the dozens of long-gone synagogues with their Jewish symbolism such as the Ten Commandments at the top of the First Romanian Congregation (Shaari Shomayim) on Douglas Boulevard, one is readily aware that this area for many decades was once the memorable, warm, vibrant center of Jewish Chicago. (Courtesy of Dr. Julius Wineberg.)

# BIBLIOGRAPHY

Bachrach, Julia. *The City in a Garden*. Santa Fe: Center for American Places, 2001.

Berkow, Ira. *Maxwell Street*. Garden City, NY: Doubleday, 1977.

Bregstone, Philip P. *Chicago and Its Jews: A Cultural History*. Chicago: Self-published, 1933.

Cutler, Irving. *Chicago: Metropolis of the Mid-Continent*. 4th ed. Carbondale: Southern Illinois University Press, 2006.

———. *Jewish Chicago: A Pictorial History*. Charleston, SC: Arcadia Publishing, 2000.

———. *The Jews of Chicago: From Shtetl to Suburb*. Urbana: University of Illinois Press. 1996.

Gutstein, Morris A. *A Priceless Heritage*. New York: Bloch Publishing Company, 1953.

Holli, Melvin G., and Peter d'A. Jones, eds. *Ethnic Chicago*. 4th ed. Grand Rapids, MI: Eerdmans Publishing Company, 1995.

Horwich, Bernard. *My First Eighty Years*. Chicago: Argus Books, 1939.

Kraus, Bea, and Norman D. Schwartz. *A Walk to Shul*. Allegan Forest, MI: Priscillo Press, 2003.

Levin, Meyer. *The Old Bunch*. New York: Citadel, 1937.

Meites, Hyman L., ed. *History of the Jews of Chicago*. Chicago: Jewish Historical Society of Illinois, 1924.

Packer, Robert. *Chicago's Forgotten Synagogues*. Charleston, SC: Arcadia Publishing, 2007.

Rosten, Leo Calvin. *The Education of H\*Y\*M\*A\*N K\*A\*P\*L\*A\*N*. New York: Harcourt Brace Jovanovich, 1937.

*Sentinel's History of Chicago Jewry, 1911–1986*. Chicago: Sentinel Publishing Company, 1986.

Shapiro, Beatrice Michaels. *Memories of Lawndale*. Chicago: Chicago Jewish Historical Society, 1991.

Wirth, Louis. *The Ghetto*. Chicago: University of Chicago Press, 1928.

# DISCOVER THOUSANDS OF LOCAL HISTORY BOOKS FEATURING MILLIONS OF VINTAGE IMAGES

Arcadia Publishing, the leading local history publisher in the United States, is committed to making history accessible and meaningful through publishing books that celebrate and preserve the heritage of America's people and places.

Find more books like this at
**www.arcadiapublishing.com**

Search for your hometown history, your old stomping grounds, and even your favorite sports team.